artists on art

First published in Great Britain in 2021 by
Laurence King Publishing Ltd
Carmelite House
50 Victoria Embankment
London EC4Y 0DZ

An Hachette UK Company

1 3 5 7 9 10 8 6 4 2

Artists on Art is based on an original concept
by Henry Carroll

A CIP catalogue record for this book
is available from the British Library.

ISBN: 978-1-78627-885-2

Design concept: Atelier Dyakova
Cover design: Mylène Mozas
Origination by F1 Colour, London
Printed in Malaysia by Vivar Printing Sdn Bhd

Laurence King Publishing is committed
to ethical and sustainable production.
We are proud participants in
The Book Chain Project
bookchainproject.com®

www.laurenceking.com
www.orionbooks.co.uk

cover: *Marina Abramović*, 2014.
Photo © Mike McGregor

ACKNOWLEDGEMENTS
Thank you to Henry Carroll, Marc Valli and Donald
Dinwiddie, who gave me the opportunity to write
this book. I am also grateful to a brilliant group of
family, friends and peers for their insight and ideas:
Kim, Amelia and Graham Black, Sebastian Holian,
Vicki Reeve, Charlotte Jansen, Kira Goodey, Steve
Hopkinson, Billie Muraben and Alex O'Neill. Finally,
a huge thank you to the artists who agreed to be part
of this book, especially the interviewees.

–Holly Black

HOLLY BLACK is an arts journalist and Managing
Editor at *Elephant* magazine. She has written for
publications including *Aperture, AnOther*, *The Art
Newspaper*, *House & Garden* and *Wallpaper*.

HENRY CARROLL is the author of the internationally
bestselling *Read This If You Want To Take Great
Photographs* series of books and founder and former
director of Frui, one of the UK's leading providers of
photography holidays, courses and events. Originally
from London, Henry graduated from the Royal College
of Art in 2005 with an MA in photography and now
lives in Los Angeles.
henrycarroll.co.uk

HOLLY BLACK

artists on art

How they see, think & create

LAURENCE KING PUBLISHING

CONTENTS

INTRODUCTION

WE ALL WANT TO UNDERSTAND THE
WORLD BETTER; THAT IS WHY ART IS SO CAPTIVATING.

Artists offer a unique way of viewing the world, turning the mundane into the spectacular and giving shape to some of society's most complex issues. While we all hope to understand and interpret a work of art when we first encounter it, there is often an impulse to know more, to discover the ways and means that brought a piece into being – not to mention the inner workings of the artist's mind.

This book hopes to shed some light on all of these considerations, while leaving space for you to draw your own conclusions. Rather than taking a chronological, geographical or thematic format, it follows an instinctive approach, coupling complementary and conflicting ideas of creativity. While it includes some great masters from throughout history, you will find that most of the voices exist in a contemporary context. The narrative also moves beyond the conventional canon. Alongside well-known greats, it showcases influential figures whose recognition is still growing in the Eurocentric art world, as well as more emerging talents, whose work continues to challenge our preconceptions every day.

This book brings together quotations from 50 artists, alongside reproductions of their work and an overview of their practice. You will find painters and sculptors, filmmakers and photographers, all of whom have distinctive views on everything from the physicality of paint to the conceptual nature of image making. There are also five original interviews, offering a more in-depth understanding of how these innovative artists go about their work.

'Artworks hold many hidden things that the artists themselves might not fully understand.'

Yasumasa Morimura

B: 1951, Japan

Yasumasa Morimura does not subscribe to the notion that truth is found by stripping oneself bare. In fact, he has spent his entire career donning ornate costuming and thick make-up, in an effort to understand his own image through the embodiment of others. These delicate mirages have transformed him into everyone from Frida Kahlo to Brigitte Bardot, and while his versions of famed paintings and photographs might seem truthful on first glance, they are often filled with playful, subversive symbolism.

Morimura considers every uncanny masquerade to be a self-portrait; an opportunity to interrogate not only his obsession with Western art history and pop culture, but furthermore the murky waters of authorship, identity and gender. He is not telling us what to see, he is taking us on a journey of discovery. In his version of Manet's *Olympia* (1863), the layers run deep. Archetypes of race, femininity and sexuality are made pliable as Morimura presents his nude form in place of a Caucasian prostitute, while simultaneously donning a wig and surrounding himself with objects that speak to the fetishization of Japanese culture. Meanwhile, he replaces Manet's attending black maidservant by dressing as a white, middle-class male suitor, greedily consuming his alternate self with a lascivious gaze. This image is both disorientating and delightful. It compels you to cast aside your preconceptions and look again.

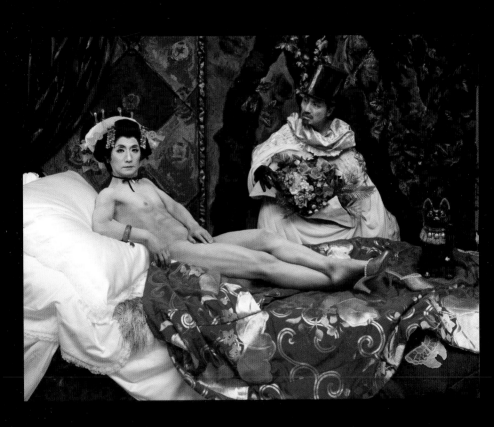

Une moderne Olympia, 2018

Nwantinti, 2012

'I'm trying to put my finger on something that moves every day.'

Njideka Akunyili Crosby

B: 1983, Nigeria

Our cultures are not static. They are constantly shifting and transmogrifying on a global and individual scale, reacting to everything from world conflict and political rhetoric, to the personal connections we make through friendship, family and everyday exchanges. Njideka Akunyili Crosby captures this movement in rich layers, building compositions that are always one step beyond our palpable reality. She paints beautifully articulated details alongside more abstract blocks of colour, as if fitting together the pieces of an intricate puzzle.

Shapes also shimmer with recollections of the artist's life in Nigeria, with magazine cuttings, photos and pop culture references pasted into the picture plane via Xerox transfer. Other signifiers are painted into being as domestic objects, architecture and intimate family scenes, forming 'contact zones' where her Nigerian and American identities collide.

Although Akunyili Crosby calls on memory and the history of painting to inform her work, she is always looking forward. Her works are filled with a vitality that does not comply to the notion of capturing a single moment in time, but rather act as a prism that refracts a whole spectrum of experiences.

'Performance is all about state of mind.'

Marina Abramović

B: 1946, Serbia

Performance is, by its very definition, an act. Its roots lie in the illusion and fantasy of the stage, and yet for the last half a century – in art terms at least – it has become something else altogether. It is now used as a vehicle to connect with an audience on the most visceral level, collapsing conventional boundaries and pushing us into new, somewhat uncomfortable, spaces.

Marina Abramović has tested the limits of her mental and physical capabilities time and time again, inflicting violence on her own body and even inviting the public to do the same in works such as *Rhythm 0* (1974). For this performance 72 items, including scissors, chains and a loaded gun, were laid on a table, and visitors were invited to interact with the objects and her body however they saw fit. The excruciating tension of this implied, and occasionally realized, threat underpins Abramović's whole practice; demanding a specific state of mind from artist and viewer alike. In order for her art to function, both parties must fully submit to the process and engage in a mutual exchange of power.

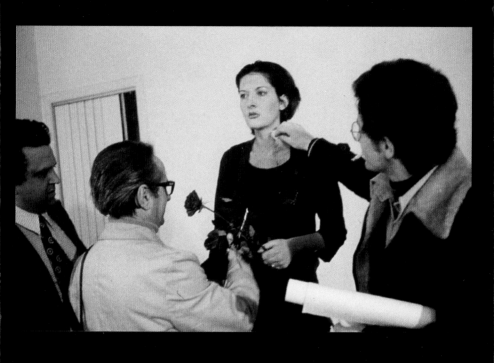

Rhythm 0, 1974

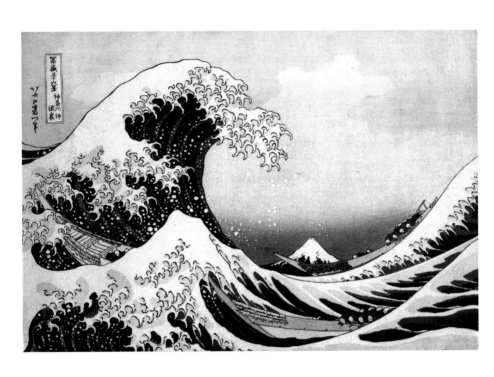

The Great Wave off Kanagawa, c. 1830–32

'At 100 years I will have achieved a divine state in my art.'

Katsushika Hokusai

B: 1760, Japan

In contemporary life we often value youth over experience. Not so for Katsushika Hokusai, the Japanese painter and printmaker who produced the iconic woodblock print *The Great Wave off Kanagawa* (1830–32), along with 45 other views of Mount Fuji, when he was in his seventies. Although he believed that artistic perfection could only be reached at the auspicious age of one hundred, it didn't stop him creating over 30,000 works during his 80-plus years on earth.

The explosive success of the *Great Wave* can also be attributed to the specific moment of its creation. Had Hokusai produced the print sooner, his roaring sea would not have been flooded with the same vital, intoxicating hue, made possible due to the invention of Prussian Blue – the world's first synthetic pigment. His interest in such Western art practices as vanishing point perspective was also symptomatic of a changing tide, with Japan finally opening its borders in the 1850s after centuries of isolationist policy. As *Japonism* firmly took hold in Europe, Hokusai's prints became the enduring image of a nation and shaped the course of modernism, thanks to the adoration of a new era of painters, including Claude Monet, Edgar Degas and Vincent van Gogh.

'I am not a historian, I am an artist.'

Lisa Reihana

B: 1964, New Zealand

As a New Zealander of British and Māori heritage, Lisa Reihana is fascinated by the ways in which cultural heritage is defined. If history has taught us anything, it is the fact that the stories of our civilizations are constantly shifting, and that the one who holds the pen, the brush (or more recently, the camera) holds the power. With that at the forefront of her mind, the artist tackles the fraught legacy of colonialism by excavating the narratives of her homeland. She peels back the layers to reveal rich visual legacies and cultural exchanges amid innumerable acts of systematic erasure and oppression.

Reihana collects these histories – whether they be folklore, traditional dance, fantastical illustrations or formal accounts – and stitches them together. She utilizes advanced animation and filming techniques to build alluring composites that move beyond the binaries of fact and record, instead creating a captivating space that speaks to the experiences of each individual, whether indigenous or colonizer.

If a historian's job is to convince us of a certain point of view, then Reihana's is to assure us that there are too many to count. By inviting us to experience these complex narratives she magnifies not only her own voice, but that of countless others who share similar stories – including those of our ancestors.

In Pursuit of Venus
[Infected], 2015–17

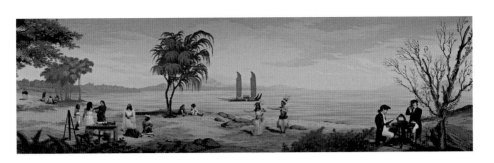

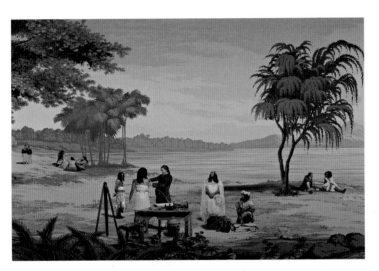

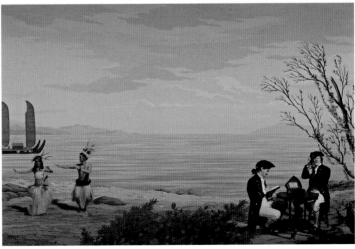

LISA REIHANA

'Every work of art is an excavation.'

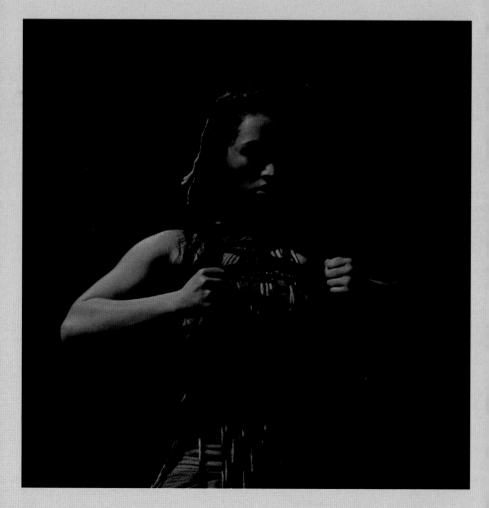

What are the primary forms of visual culture that have influenced you as an artist?

Being of Māori descent, I am surrounded by beautiful visual images, sculptures and weavings, which reflect the Pacific design that permeates this part of the world. New Zealand – or Aotearoa, if we are to use our name for this part of the world – has a British colonial history, and when I was growing up, being Māori wasn't as 'cool' as it is now. There was this whole colonial mandate to get rid of our language and the impact of this censorship has been far-reaching. When I was younger I went up north to my father's tribal homeland, but I didn't find much in the way of visual material. This sense of loss made me want to fill the space. The absence became very influential on my practice.

What about specific artists? Does anyone in particular come to mind?

When I was at art school I saw a wonderful exhibition by a Māori artist, Ralph Hotere. He would take huge pieces of stainless steel and then take to them with power tools leaving spectacular marks and burnt edges. These shiny drawings had such an incredible power because they were so visceral and immediate. It was the first time I saw his work, but years later I discovered that he's from the same tribe as my ancestry. He's a very, very important modernist artist, not caught up in the traditional visuality of Oceania. He has his own raw energy.

Te Wai Ngunguru -
Nomads of the Sea, 2019

You have developed a very specific filmic language that alludes to traditional animation and historical illustration. How did you come to it?

When I was young my mother did a lot of amateur theatre and I used to go and sit behind the scenes. It's an interesting thing because you're seeing the production performance as well as the audience's reaction. That knowledge between the making of a performance or a film and how it interacts with the audience to create the full experience fascinates me.

Later, when I was at high school, I used to help my sister who ran the paint departments of the animation studios. I became involved in the filming part, where you swap out all of these different painted characters. We'd always start at night, then drop the film to the processors in the morning and have it back by the afternoon. I love the magical nature of bringing still objects to life.

Being a filmmaker really suits me because it basically encompasses everything: writing, collaborating, costume design, sculpture, making props and digital technology. As we were shifting through this post-colonial period in New Zealand [in the 1980s] questions came up such as 'Can you call yourself a Māori artist if you don't speak the language?' I didn't have the language because I'm first generation and urban-born but utilizing a lens-based practice has allowed me to transgress traditional ideas in a way that feels comfortable. People would say things like 'Women don't carve', so I use Photoshop and other materials as a carving tool. It is a strategy that has allowed me to reclaim my voice.

An epic, panoramic video work like *In Pursuit of Venus [Infected] (2015–17)* certainly feels highly crafted. It is beautiful to look at but also so densely packed with all these different ideas about colonialism

and cultural exchange, based within the context of Captain Cook's voyage. There is a fusion of animation and film that seems to carve the characters out of the illustrative backdrop. Your eye is constantly moving, to discover the next story.

You can be very political with animation because of that magical quality. With *Venus* you see an audience with two-year-old kids sitting next to eighty-year-olds and they are equally engaged. It's that mystical nature of trying to understand and unpack what is happening and what you are seeing. You can entice people and tell a story on a multitude of levels by using this form. It is an egalitarian way of creating artworks, which allows people to talk to each other and share their point of view. I like video installation for this very reason, as opposed to the one-point perspective you experience in the cinema.

Your work is also very technologically complex. You have rebuilt computers and utilized over a trillion pixels to present *Venus*, as well as conceiving lighting installations and a 3-D, four-channel video in *Nomads of the Sea* (2019). Have you always been into tech?

I like technology, and I've always been interested in what photographic images have to tell you. New Zealand was the last land on earth to be populated. It has been only hundreds of years since we were colonized, as opposed to thousands elsewhere, so photography plays a really big part in our cultural memory. It fills in the blanks and sets the way we see ourselves. I like to reference history and then skew it, because I don't want to just live in the past, I want to imagine a new future.

That sense is palpable in *Venus*. Despite being based on the early-nineteenth-century scenic wallpaper *Les Sauvages de la Mer Pacifique* (produced by Mr Jean-Gabriel Charvet and Mr Joseph Dufour), the characters seem contemporary and relatable. I think this comes from the way you offer these vignettes in different scenes, where each person has their own agency. It isn't a one-dimensional viewpoint.

Because it has this historical aspect, people forget that *Venus* is unbelievably contemporary. Just think of the digital material and the production processes, which are very much up to the minute. But it's also the fact that the people – the talent – who are in the film are the living, breathing faces of our ancestors. I also wanted to place artists front and centre, because they are responsible for developing the visual languages we recognize. For example, there are a couple of scenes where a tattooist implements a hybrid style, because these cultural encounters gave rise to new forms of artistic expression.

There's also this slippage. *Venus* is a contemporary telling of our idea of what we think the explorers and those they encountered did, not necessarily what history says happened, which relates to the larger telling of colonial histories. Photographs and illustrations set the visuality of culture, which isn't actually true or real, but as indigenous people you get stuck in this perpetual historical idea of what someone else claims your people to be, which is essentially someone else's view of who you are.

You mention skewing the narrative, and I see that clearly in *Nomads,* which focuses on female-dominated stories, and *Venus,* where Captain Cook is played by a man and a woman. Queering these histories feels like an important, current conversation to be having, but it also serves as a reminder that

the binaries of sexuality, gender and the patriarchy are not universal, or defined by European history.

Sometimes people are just waking up! I went through art school from 1983 to 1988 and around that time there were a lot of discussions around gay rights and what is described as the Māori Renaissance. It was a moment in time when Tino Rangatiratanga or Māori rights were being asserted, and there was a real push towards broadcasting and air time and awareness around language retention as it was being lost. These things are not new by any stretch of the imagination, but we've got to make sure they don't get lost in amongst the noise of our world.

You have described beauty as 'a political act'. Can you tell me a bit more about this idea, in relation to the function of art?

Recently, I was looking at *Sensation* [a famous exhibition by the Young British Artists mounted in 1997], which captured people's attention by using ugly things or being really in your face. I'm not interested in that at all. I'm concerned with putting time into something, highly crafting it, and making sure it has resonance – that it keeps on giving. I don't want to make throw-away works; there's already too much waste in the world. It's also a feminist position. In the previous century female creativity was limited to the garden or the home; that is where they flourished. They created things that related to everyday life, and I'm all about holding on to that productive space.

The burden of deconstructing colonialism is often placed on people of colour, who are held to a higher standard of accountability than their white counterparts. As a person of Māori heritage who is navigating ancestry in your work, do you feel pressured to be an educator as well as an artist?

Yes and no. I do want to communicate as well as I possibly can, because it is an act of generosity to share these deep ideas. However, as a cultural woman I can easily be pulled up and accused of changing histories or showing them differently. I'm often walking a tight line between tribal knowledge; a general audience; specific histories… there's always something that I have to negotiate. There's a responsibility in being a spokesperson but I'm not a historian, I am an artist. I want to create more opportunities to share the things that I know, because what I do get to learn is unbelievably fantastic. There's so much knowledge that has been lost for my people, so every project presents an opportunity to discover more. Every work of art is an excavation.

LISA REIHANA
Born and based in Auckland, Reihana represented her New Zealand at the 2017 Venice Biennale and has exhibited globally, including at the Royal Academy of Arts in London, the 2019 Sharjah Biennial, the Brooklyn Museum in New York and the Palais de la Porte Dorée in Paris. In 2018 she was made a Member of the New Zealand Order of Merit.

'We need to know that virtuality has changed the way reality works.'

Cao Fei

B: 1978, China

Not so long ago, online realities were considered the dominion of computer nerds and kids – a place to live out juvenile fantasies, play games and take refuge from the real world. Nowadays, we all live double lives. We communicate through any number of apps and electronic devices; present ourselves in ever-extreme digital forms; and build entire networks without so much as a single face-to-face meeting. The virtual plane is now fused with tangible existence.

Cao Fei saw this coming. Over a decade ago she understood the creative potential of *Second Life* – a user-created online universe that allows people to construct entirely new realities for themselves via their avatar – and conceived an artist-led community called *RMB City* (2007–11). This 'condensed incarnation of contemporary Chinese cities' reflects the hyper-accelerated urban and consumerist development of metropolises like Guangzhou (where Cao was born), building on a filmic practice that had already begun to plunge the depths of youth disenfranchisement and the hostile realities of the new industrialized labour force. In *RMB City* users could visit major landmarks, attend events, collaborate on art projects and even buy up land, blurring the lines of the virtual and the physical, and foreseeing a new era of ever-evolving reality.

RMB City: A Second Life City Planning, 2007

'If you don't maintain physical contact with the material, the work might end up not having a soul.'

El Anatsui

B: 1944, Ghana

Forging emotional connections with an inanimate object usually stems from some form of sentimentality. While it might not seem important to someone else, the representational value is clear to the owner. Such care is rarely afforded to the ubiquitous packaging we dispense with every day, and yet El Anatsui believes that every substance has worth, which is heightened by the imprint of the many hands through which it has passed.

As a result, it is discarded items found close to his studio in Nsukka, Nigeria, that hold the most interest for El Anatsui. The artist uses bottle tops, tin cans and copper wire to create vast, modular sheets that sit somewhere between subversive textile and malleable sculpture. He works with an army of assistants to carefully craft these modular surfaces, which take on no prescribed form. Anatsui prefers to physically mould every piece to the environment in which it is hung, and even leaves installation entirely up to interpretation. With each exchange, he attests that the work is imbued with not only the spirit of the artist, but also the countless other hands that have brought it into being.

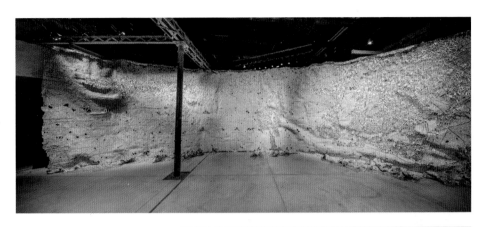

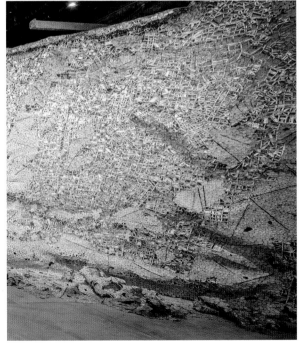

Earth Shedding Its Skin, 2019

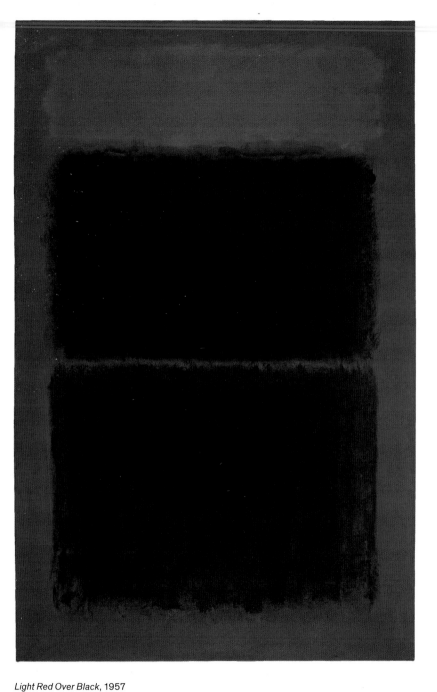

Light Red Over Black, 1957

'What is the popular conception of the artist? Gather a thousand descriptions, and the resulting composite is the portrait of a moron.'

Mark Rothko

B: 1903, Latvia

Although Mark Rothko's statement might seem damning, it reveals a lot about the way artists are perceived by the masses. The toxic image of a creative, tortured genius is still pervasive, fuelling the notion that inspiration comes only from a raw psychological state that is beyond reason. Furthermore, an artist might be incapable of managing their everyday affairs or maintaining functioning relationships, but that is the price they pay in order to achieve greatness.

It is ironic that this incisive criticism comes from an artist whose paintings are defined by their visceral power. Rothko once declared that he was interested in expressing only basic human emotions – such as 'ecstasy' and 'doom' – and strove to move his audience to tears. As one of the giants of Abstract Expressionism he had no interest in portraying the figurative world, instead developing his own intense visual language that is defined by luminous blocks of colour. They appear in an exquisite haze that seems to float above the surface of the canvas, merging and blurring in a manner that is never truly fixed. Looking at a Rothko is an exercise in sensation, which might well ignite a feeling beyond comprehension.

'I modelled with my sculptures, which for a fine artist was sort of disgusting.'

Marisol Escobar

B: 1930, France

Should artists cultivate their self-image along with their work? There are plenty of arguments for and against, but there is no denying that women are more likely to be labelled narcissistic or frivolous if they choose a path of visible self-promotion. Marisol Escobar is one such case. As a young artist working in New York in the 1950s she worked tirelessly to develop her own aesthetic, carving huge hunks of wood into effigies of modern society and using a pop art sensibility with influences of pre-Columbian sculpture.

Failing to fit into any particular genre, and certainly not fitting in among the veritable 'it' group that were the Abstract Expressionists, Marisol (who preferred to go by only her first name) blazed her own trail. She worked as hard on the party circuit as she did in the studio, rubbing shoulders with celebrities, taking roles in Andy Warhol's films and posing with her sculptures for *Vogue* and *TIME*. Some might condemn her for it, but by shrewdly harnessing the power of publicity she really did push her practice into the realms of public consciousness. Just remember: no one can recognize your talent if they can't find it.

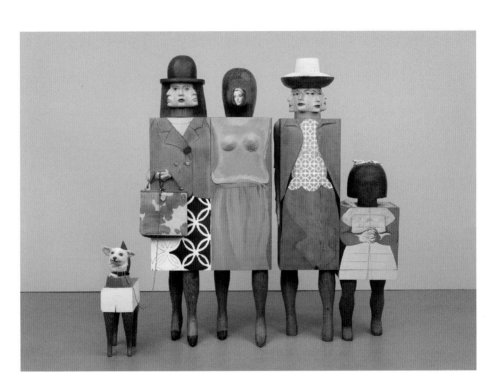

Women and Dog, 1964

Bank Bond, 2013

'I have never had the luxury of art just being art.'

Theaster Gates

B: 1973, USA

Theaster Gates truly believes in the transformative power of art, due to the fact that he has an expansive view of the term. The Chicago-born artist did not come to his practice in the most linear fashion. He originally studied urban planning as well as ceramics and religious studies, which led to a more granular understanding of how culture can enrich communities. For Gates, art is not solely a series of objects to be marvelled at; it is music and poetry and history and storytelling and land.

Consequently, his work is embedded as much in fostering cultural space as it is in objecthood, exemplified by his non-profit organization, Rebuild Foundation. By purchasing vacant lots in his local area of Greater Grand Crossing, including a 17,000-square-foot bank, he has rejuvenated the neighbourhood, creating venues for arts programming, local amenities and live-work residencies, as well as permanent homes for important archival collections that preserve the legacy of black history, including vinyl, books, slides and periodicals.

Despite the profound impact of these 'socially minded' enterprises, Gates often finds that people attempt to separate them from his wider studio practice, somehow negating the significance of this work as something other than integral. The artist sees no such division. For him, creativity is all about being productive, whatever form that might take.

'Objectivity or fairness in discussing art is impossible.'

Max Beckmann

B: 1884, Germany

Max Beckmann knew the power of subjectivity all too well. He was condemned at the infamous 'Degenerate Art Exhibition' in 1937; an elaborate form of Nazi propaganda that sought to 'educate' the public on the ills of modernism. Throughout the 1920s Beckmann had enjoyed acclaim as a principal member of the New Objectivity movement, which rejected avant-garde idealism for brutal realism. His work was informed by a traumatic term as a combat medic in World War I, and his subsequent cynicism during the instability of the Weimar Republic was prophetic.

Denounced as a 'cultural Bolshevik', he fled his homeland immediately after the exhibition opened, creating *Bird's Hell* (1937–38) in exile. The nightmarish scene is reminiscent of Hieronymus Bosch's gruesome triptych *The Garden of Earthly Delights* (1490–1500), which depicts a fantastical, unending cycle of human suffering. Beckmann's interpretation features a flock of sadistic monsters torturing their victims, while surrounded by hordes of saluting humanoids. His claustrophobic scene evokes nothing but horror, even if you remain naïve of the context. Perhaps, then, the artist's statement can be refuted. While every individual brings their own experience and judgement to this painting, we are all united in Beckmann's eternal nightmare.

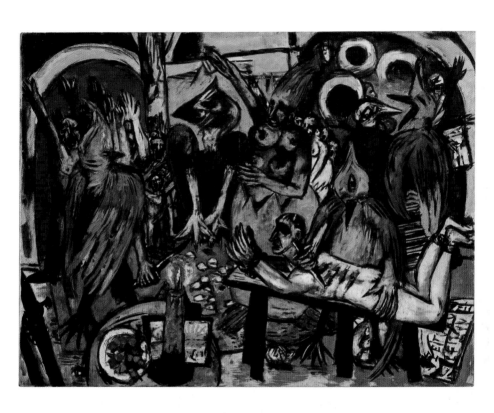

Bird's Hell, 1937–38

SHE IS GONE, AND THE AFTERMATH OF GUN VIOLENCE, WITH ITS PHYSICAL, EMOTIONAL AND FINANCIAL REMINDERS, ARE WHAT I AM LEFT TO RE-CREATE HER WITH.

VIGIL, 2019

'I like placing content wherever people look, and that can be at the bottom of a cup or on a shirt or hat or on the surface of a river or all over a building.'

Jenny Holzer

B: 1950, USA

Never one to be limited by conventional gallery spaces, Jenny Holzer has applied her text-based work to all number of surfaces, in an effort to break through the barriers that are wedged between the general public and the art world establishment. She reminds us that art can take place anywhere, and simple forms often hold the greatest of complexities.

Holzer is best known for her use of LED projections, used to broadcast various one-liners or *Truisms* in an endless loop, both in carefully composed sculptural setups and on commercial billboards and signage. Yet this is by no means the only way that she has disseminated her aphorisms. She began pasting posters of her hand-typed missives and handing out loose sheets to passers-by back when she was a student, in the hope that they might prove thought-provoking, anger-inducing or hilarious.

Since then, her text has appeared on everything from baseball caps to skyscrapers, amplifying her own voice as well as others, in increasingly explicit tones. While she once declared that 'abuse of power comes as no surprise', she has used her position for a wider public good. A prime example is *VIGIL* (2019), which saw testimonies from victims of gun violence projected on an enormous scale on the side of the Rockefeller Center in New York. Such a bold project is unmistakable in purpose and unapologetic in its visibility.

'Ideas are ideas – and not art. Art is what you make of the ideas.'

Ibrahim El-Salahi

B: 1930, Sudan

An idea is only the beginning of a long creative process. It is a seed that has the capacity to grow and branch off into any number of different directions, or it could wither and die. It might only work when thrown together with other seeds, or successfully germinate after years of lying dormant.

Whatever the outcome, Ibrahim El-Salahi attests that an idea is but a starting point. In fact, he harnesses a twofold power when beginning to draw or paint: on the one hand calling on a wealth of external references that have slowly embedded in his consciousness, and on the other, allowing his very being to operate as a conduit for Islam, in which the symbols of spirituality flow through him. It is an assemblage of ideas that inform his hand, some of which are entirely unconscious.

The result is a distinct blend of modernism that calls on the 'Africanized arabesque style' seen in his father's transcriptions of the Qur'an; the everyday shapes and forms prevalent in Sudanese culture; and other mysterious, less discernible subjects. His visions glide between solid, geometric slices and hazy delineations, which almost slip away before your eyes.

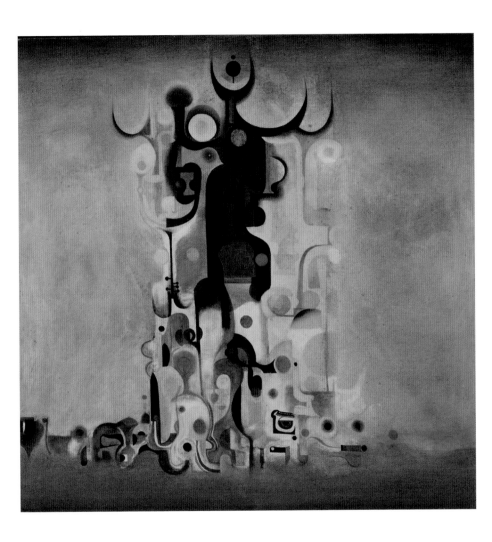

Vision of the Tomb, 1965

"Untitled" (Public Opinion), 1991

'The studio is a scary stage set.'

Felix Gonzalez-Torres

B: 1957, Cuba

The artist's studio has long been considered a vital component to creative practice; a place where ideas can be incubated, whether it be in solitude or surrounded by an army of assistants. However, for American artist Felix Gonzalez-Torres the idea that art should be conceived within this designated realm was ultimately flawed, inducing what could be interpreted as a form of stage fright.

Instead, he worked from his New York apartment or elsewhere, rarely producing conventional preparatory drawings or detailed notes. By eschewing these traditional measures of creative practice Gonzalez-Torres created his own rules, presenting installations of stacks of paper and piles of sweets, while giving visitors the choice to take a piece for themselves. Furthermore, he gave no instructions on how to mount an installation comprising a string of lightbulbs and produced billboards that seemed to celebrate intimate yet banal scenes of a bed, a sky or a hand.

By refusing to submit to the accepted framework of an artistic style, or a mode of production, Gonzalez-Torres rejected the norm, and built a language that referenced issues of identity, sexuality and the Aids crisis, in a manner that rejects sensationalism and demands thoughtful contemplation.

'My work is about brokering.'

Lubaina Himid

B: 1954, Zanzibar

The act of negotiation might not seem like the most obvious calling for an artist, but for Lubaina Himid, it is vital. She has been navigating society's power structures for decades, countering the marginalization of the black experience in both the mainstream media and the art historical canon through painting, installation and collage. But Himid's work does not stop there; she is also a writer, curator and educator, going beyond the conventional role of the artist to upend the status quo, righting the wrongs of historical erasure and celebrating the huge contributions of the diaspora.

She speaks of dialogue as a means of pulling apart the narratives that so often define us, as seen in works such as *Naming the Money* (2004), which gives an individual name and voice to 100 black figures who have been reduced to supporting roles in aristocratic portraiture, and *Between the Two My Heart is Balanced* (1991), a reimagining of a composition by French artist James Tissot. Himid's version replaces the trope of a man caught between two lovers with an image of two defiant black women, steering their own course upon the high seas.

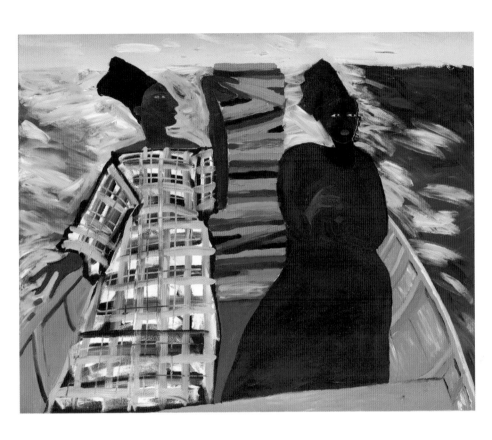

Between the Two My Heart is Balanced, 1991

'You first need to master the know-how; then you can create your own codes.'

Abdoulaye Konaté

B: 1953, Mali

Abdoulaye Konaté understands the importance of looking back in order to move forward. He is best known for producing multi-layered textile works that recall the ribboned costumes worn by Senufo musicians, as well as drawing on Mali's rich history of fabric production and dyeing. However, his material practice moves far beyond a simple replication of age-old tradition. These vibrant textural surfaces span figuration and abstraction to tackle concerns as expansive as global conflict, immigration, ecology and health crises.

Konaté's mastery is not limited to the role of artist, either. As the founder of the Balla Fasséké Kouyaté Conservatory in Bamako, where he lives and works, he has reshaped arts education by observing an interdisciplinary approach, where all forms of cultural creation are celebrated. Painting, sculpture, dance, music, design and digital arts are taught with an equal appreciation for Malian and international methods. By marrying these elements, the artist has built a new creative code, resulting in a symbiotic balance where neither old nor new need be disregarded, and establishing an enduring legacy in the process.

Composition au triangle violet, 2019

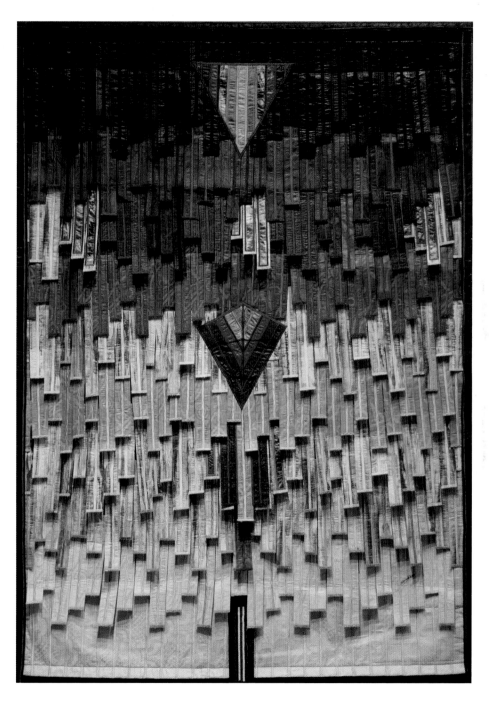

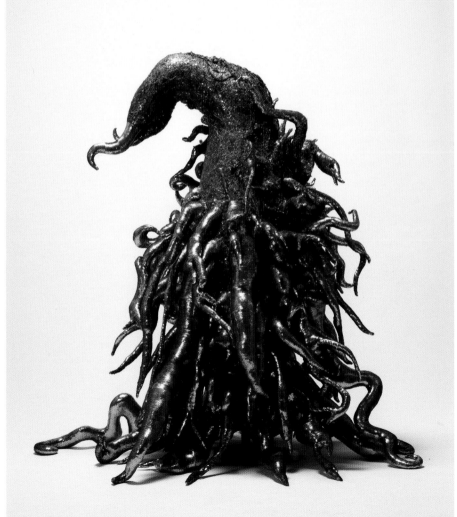

'I don't believe in any "isms".'

Lee Bul

B: 1964, South Korea

To some extent we are all fans of labels. We like to categorize everything, in an attempt to neatly define the complexities of humanity and hopefully understand it better. However, in terms of creativity – and much else – such categorization is rarely helpful. Lee points to 'isms' (the catch-all suffix that identifies a vast array of topics, from feminism to altruism) to describe the manner in which artists find themselves catalogued or grouped along arbitrary lines, such as nationality, gender or medium.

Lee loathes being pigeon-holed, not least because her practice is exceptionally broad. She is not defined by her place of birth, her childhood or her country's politics, but she is enriched by them. These reference points allow her to build a complex nexus of allusions that knit together subjects as disparate as twentieth-century philosophy, karaoke booths, historical disasters and anime. She builds terrifying tentacled creatures that appear to have smashed through a mirrored domain, and structures that could be interpreted as either microcosmic cities or luxurious chandeliers. She adorns stinking fish with intricate beading, and delicately applies acrylic paint to panels of silk, all of which build a vision of a fantastical, futuristic universe.

Monster: Black, 2011
(reconstruction of
1998 work)

'Geography can hardly be the only a way of deciding how a work will be understood.'

Shilpa Gupta

B: 1976, India

The arbitrary nature of our manmade borders is an ongoing concern for Shilpa Gupta. The artist has traced the varying lines of South Asia and elsewhere, examining how culture, community and the notion of home have been carved up and destroyed through political upheaval and declarations of essential security. She examines the spaces where these borders exist, where gigantic fences are built to separate communities which have been in existence longer than nation states came into being and airports engage in hostile passenger profiling and numerous luggage checks. In *Untitled* (2019), for example, a mechanized gate continuously swings and smashes against a wall in a form of perpetual destruction, while in the interactive series 'There is No Explosive in This' (2007) the artist challenges visitors to put themselves under suspicion by taking a bag emblazoned with the phrase on their various travels.

We are often encouraged to interpret a piece based on the context of its surroundings and make assumptions on how a particular environment might shape its understanding . Yet Gupta believes that art can transcend the space in which it sits and connect with how we live not only on a physical level, but socially and philosophically. She attests that, even if a work is made in Mumbai, it might speak more to an audience in Cuba, because our identity and experience are never homogenous, and rarely fixed.

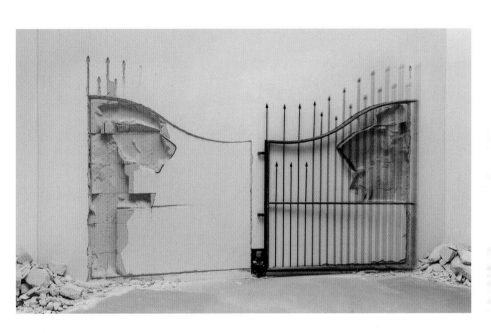

Untitled, 2019

It was all too much, 2018

'Without art, I am one hundred per cent sure I would be dead.'

Tracey Emin

B: 1963, UK

Tracey Emin has never attempted to be anything other than an artist. In fact, she has repeatedly said that she doesn't know how to do anything else. It is not an arrogant claim, but rather a statement of fact that making art has been her lifeline – a way to process and confront her internal demons and the ills inflicted by others.

Emin spent the early part of her career being vilified by the media, for daring to show a deeply personal account of the uglier side of modern existence. She has produced a tent appliquéd with the names of everyone she has ever slept with; a heart-breaking film recounting her abortion; a form of radical self-portraiture in *My Bed* (1998); violent, frenzied paintings; and lines of neon text that flit between poetic and acerbic. As time has gone on Emin has never changed her stance, but public perception has shifted. In an age when women's voices are finally being amplified and listened to, her work is an essential record of not only the pain and suffering that has often been silenced, but also the raw power of sensuality, anger and love.

TRACEY EMIN

'I've only ever made art – I've never done anything else.'

How it Feels, 1996

Do you remember the first time a work of art had a profound effect on you?

Yes, I have two clear memories. The first time was when I saw an Egon Schiele painting in a book and I realized there was art for me; I was about fifteen or sixteen. The next time was during my first visit to the Tate gallery, when I was twenty-two. I stood in front of Mark Rothko's *Untitled (Red, Black, Orange and Pink on Yellow)* (1954) and began to cry. I have no idea why I was crying, I just couldn't stop. At the time I thought it was because I felt overwhelmed by the Tate. It was only later that I understood what I had felt, which was the sadness in Rothko's work.

When you opened your first exhibition you declared that your art career started on the day you were born, but was there a definitive moment when you knew you were going to be an artist?

This question is hard to answer because the answer usually reflects the mood I am in. I've only ever made art – I've never done anything else, I've never ever tried to do anything else, but I would say the moment that was like an epiphany was the opening of my exhibition at the South London Gallery, 'I Need Art Like I Need God' in 1997. That was the moment I thought that maybe I could actually do this.

Do you think great art needs to tell you something about the person who created it?

From my personal point of view, yes, but maybe not necessarily. A great minimalist might be an amazing driver or a fantastic lover, but you are not going to be able to tell by looking at their work. Or are you?

Last time we spoke you explained that you could spend years painting a single work, until it tells you something new and has a reason to exist. But do you ever find it impossible to continue, even if a work is unresolved?

I never throw a canvas away. I just keep painting and painting until it's resolved. I only destroyed all my student work because I had nowhere to keep it.

Is it possible to describe the moment when you know a work is finished?

No. Often I make a mistake, paint over it, then ruin the whole painting, which obviously means I have to start again.

You have mentioned the significance of your own handwriting in your neons, as well as the natural, imperfect lettering on your appliqué blankets. Does the physicality of the text hold as much significance as the words they spell out?

Yes;, one isn't less important, but it becomes more important once I've touched it. The words are always significant because that's the essence of something that goes around inside me. When I've written it out, it's part of me – but out of me.

Would you say that drawing is your first love? It seems like a lot of your work harks back to it, whether it is the cursive characters of your neon text, or the line work in your paintings and mono prints.

No, writing is my first love. Because all I need is a pen and paper.

How does it feel to experience your work in dialogue with other artists? I'm thinking of exhibitions such as 'Tracey Emin and William Blake In Focus' (at Tate Liverpool in 2016–17), 'My Bed/ J.M.W. Turner' at Turner Contemporary, Margate (2017–18) and, of course, your collaboration with Louise Bourgeois, where you overlaid drawings on paintings sent to you by the artist?

It's really lovely working with art from a different time, people of a different age. I learn something. It was my initiative to put the bed with Francis Bacon [Tate Britain, 2015]. It seemed really happy there.

Is there an artist that you would love to see your work exhibited with, which hasn't happened yet?

I am about to see my work shown alongside Edvard Munch at the Royal Academy of Arts [2020–21]. This type of intervention takes up so much mental energy that I think Munch will be my last.

I know that you install *My Bed* yourself every time it goes on display, and I wonder if you have considered how it might be constructed when you're no longer able to? It is probably one of the few works of contemporary art that deserves the title 'iconic', so there will undoubtedly still be great demand to see it when we are both long gone.

There is lots of archival film and notes of me installing it. It's already over 20 years old. The world is such a different place from when I first created it.

You have grappled with experiences of rape, sex, abortion, depression and emotional trauma in your art, beginning at a time when people were quick to condemn you. How does it feel to have your work reappraised in the wake of movements like #MeToo, at a point when more women's voices are beginning to be listened to and hopefully being better valued?

It still hurts, the fact that I wasn't taken seriously. A blot on my career that could have amounted to arrested development – but fuck them.

Do you think art can change the world?

Yes, art changed my world. And without art, I am one hundred per cent sure I would be dead.

TRACEY EMIN

Emin works in her studios in Margate, London and the Côte d'Azur. She is a Royal Academician, and has exhibited at London's Hayward Gallery, Turner Contemporary in Margate, the Musée D'Orsay in Paris and the Leopold Museum in Vienna.

'For most people, if something disturbs them they recoil, they pull back – over the years I've trained myself to do the opposite.'

Arthur Jafa

B: 1960, USA

Arthur Jafa is not afraid to confront disturbing material head on. Already an acclaimed cinematographer, he was recently heralded as a ground-breaking artist following the release of his film *Love is the Message,: The Message is Death* (2016). Set to Kanye West's gospel track 'Ultralight Beam', it comprises a mosaic of moving image clips that reference African-American culture and history. Jafa montages scenes of joy, intimacy, brutality and suffering, from footage of civil rights marches, sports broadcasts and personal home videos to snatches of iPhone recordings that capture acts of violence inflicted on black people by white supremacists as well as police officers.

Jafa is not naturally drawn to distressing things, but he has trained himself to look while others turn away. Such action relates to the fact that the ability to escape cruel realities is a privilege – one that is not afforded to the communities who find themselves the subject. Jafa believes that his responsibility lies not in finding beauty in everything, but rather in revealing the complexities of the African-American experience, in a manner that matches what he refers to as, 'the power, beauty, and alienation of black music'.

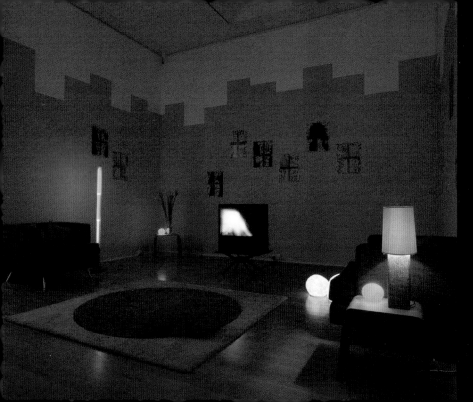

'I am very intrigued by the distinction between literally reading and understanding signs or marks, and interpreting them.'

Susan Hiller

B: 1940, USA

What is the difference between reading and interpreting? In language you could look to the liminal spaces where translation fails and gaps of meaning are filled by decoding inflection, emotion and past experience. The same can be said for art. Two people can examine the same work and arrive at completely different conclusions, depending on their childhood memories; their relationship to their loved ones; their deepest hopes, dreams and fears.

Susan Hiller trained in anthropology before becoming an artist, and although she collected all manner of objects with fervour, she did more than simply categorize and quantify her findings. She referred to her practice as 'paraconceptual', bridging the gap between academic method and the spirituality of an artefact, embracing the paranormal realm beyond.

The profound effect of this process is best expressed in *Belshazzar's Feast* (1983–84). This room-sized installation builds an eerie *mise-en-scène* in the form of a familiar domestic setting, with sofas, house plants and a television broadcasting a roaring fire – the flickering flames of which act as a vehicle for reverie, allowing viewers to envision faces and figures. It was inspired by a series of newspaper reports claiming that supernatural forces were haunting TV screens long after official programming had ended.

'A painting cannot change things, it shows things, that's all.'

Kerry James Marshall

B: 1955, USA

Such a statement could be interpreted as rather pessimistic, were it not spoken by an artist whose practice is defined by rendering the invisible visible. From an early age Kerry James Marshall was fascinated by pictures, wondering at the cornucopia of images pasted in a school teacher's scrapbook, and later marvelling at the works of Rembrandt, Ingres and Delacroix. He was struck by a desire to reach this level of profound mastery, but nevertheless understood that these grand paintings supported a prevailing narrative of white superiority, in which people like him were rarely featured.

As a result, Marshall creates paintings that celebrate multifaceted blackness, presenting his figures in a stylized ultra-black tone and situating them in planes of existence that blend scenes from everyday life with art historical tropes. In building what he calls a 'counter-archive' he elevates seemingly mundane spaces and activities including barber shops, nightclubs and family get-togethers to a grand level, as well as touching on the politics surrounding the appreciation and consumption of art, as seen in *Still Life with Wedding Portrait* (2015), where a work's painstaking installation becomes part of the narrative. Though Marshall might refute that a painting can galvanize direct action, by showing things that have long been absent from our museums and galleries, he is effecting the change we need to see.

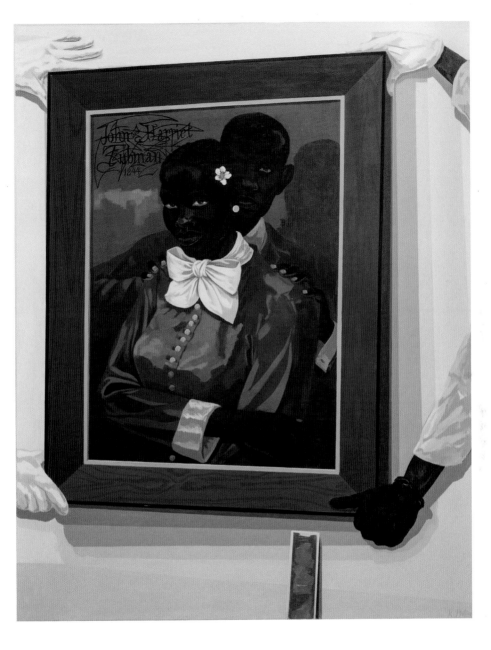

Still Life with Wedding Portrait, 2015

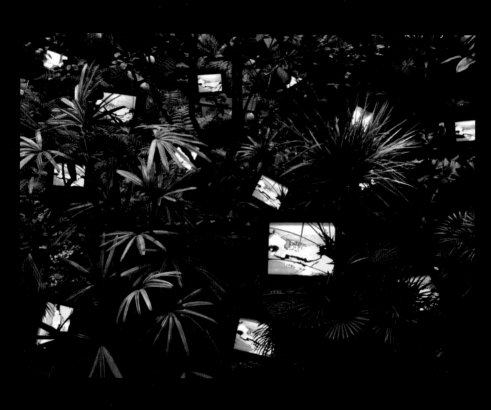

TV Garden, 1974–77/2002

'[I want] to shape the TV screen canvas as precisely as Leonardo, as freely as Picasso, as colourfully as Renoir, as profoundly as Mondrian, as violently as Pollock and as lyrically as Jasper Johns.'

Nam June Paik

B: 1932, South Korea

Nam June Paik was a prophet of the digital age. He coined the term 'electronic superhighway' in 1974, as a way of describing our imminent, hyper-connected global future, but he also saw the artistic potential of video and computer technologies, in a way that no one else could fathom.

Paik drew from a huge number of influences, marrying avant-garde performance and musical composition with principles of Zen Buddhism. He experimented with the physical and ephemeral nature of technology, using magnets and synthesizers to distort audio-visual equipment and redefine their capabilities, as well as building anthropomorphic robots from defunct television sets and radios.

This playful approach not only humanized a world of wires and monitors but also foretold of an era where culture and technology would become inseparable. In *TV Garden* (1974–77), for example, he imagines an environment where electronics and nature coexist. The presence of these televisions, nestled among dense foliage, imbues them with some sort of living, wild spirit. Moreover, each set displays the video work *Global Groove* (1973). This montage of fast-paced footage mixes snippets of high and low culture, from Beethoven's 'Moonlight Sonata' to Japanese commercials. Images slip and slide across the screens, morphing into each other before exploding and dissipating, in a dynamic form of art-making that revolutionized our visual language.

'I am not interested in conservation. If something falls down, it has meaning.'

Anselm Kiefer

B: 1945, Germany

Everything about Anselm Kiefer's work is colossal. He is uninhibited by the limitations of the canvas, gouging and scraping at thick layers of oil paint and adorning his surfaces with everything from charred wood to barbed wire. Likewise, his monumental sculptures take the form of vast, spectral structures built from corroded, sinewy metals and disintegrating found objects. Stand among these works and the weight of their presence threatens to crush you.

While the shadows of post-war Europe have proved somewhat influential for Kiefer – who was born while bombs still raged – he seeks inspiration from sources that speak to the expansive, cyclical nature of the universe. He looks to Norse mythology, Hebrew folklore, alchemy and theoretical physics to build dense imagery that is too often interpreted as simply apocalyptic. While some might see wastelands and abject destruction, Kiefer sees vitality and resurrection. This attitude extends to the physical properties of his paintings and sculpture. He embraces the ravages of time, while others might strive to suspend it in an effort to preserve a moment of imperceptible genius. Instead, his art buckles and shifts, constantly evolving and reforming under the burden of its own existence.

The Living and the Dead, 2017–18

'Seeing is no longer believing. The very notion of truth has been put into crisis.'

Barbara Kruger

B: 1945, USA

If the truth will set us free, are we destined to be imprisoned forever? It might seem that way, considering the evermore malleable definitions of fact. In such moments we need an artist like Barbara Kruger, whose distinct graphic style and deft phraseology predate the advent of viral tweets and clickbait and offer something far more profound.

Kruger's genius stems from her simple visual code. She overlays black-and-white imagery with red blocks filled with the bold letterforms of Futura. Her aphorisms denounce the ills of our age, from rampant consumerism ('I shop therefore I am') to gender politics ('Your body is a battleground') and mob mentality ('Hate like us') – laying the flaws of our society bare. Kruger's career began in graphic design, which goes some way to explain her astute ability to harness the visual power of text, as much as its literary meaning. Her work has subsequently taken over everything from billboards and magazine covers to immersive museum installations. Whatever the medium, she maintains a canny ambiguity that is always open to interpretation; it simply depends on which truth you choose to follow.

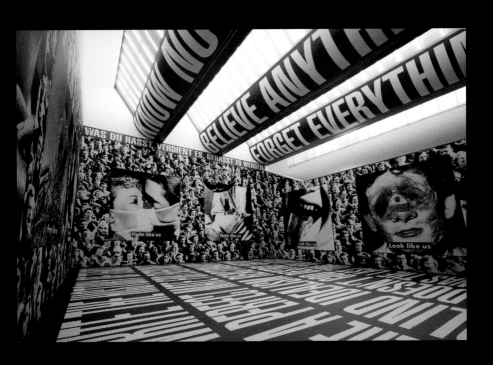

(Untitled), 1994/5

Aggregation: One Thousand Boats Show, 1963

'As an obsessional artist, I fear everything.'

Yayoi Kusama

B: 1929, Japan

Fear and dread might not be the first things that come to mind when viewing Yayoi Kusama's motifs of dots and pumpkins. Although the epically Instagrammable artist has stated that she always wants to spread joy among her audience, her own relationship to art is much more complicated.

From a young age Kusama experienced hallucinations, a phenomenon that has plagued her throughout her life. Drawing functioned as a way to mentally process these episodes, which often manifested as clusters of dots that obscured her vision. Since then her practice has been defined by obsessive repetition, including densely crowded paintings; sculptural 'accumulations' that cover everyday objects in hundreds of phallic forms; and thousands upon thousands of dots, covering pumpkins, mirrored installations and more.

Kusama considers making art to be a form of therapy, but she has also been upfront about her need for professional help. She has resided in a hospital facility for decades, while continuing a prolific studio practice. In a society where mental health is often overlooked, misunderstood or dangerously associated with talent, artists like Kusama demonstrate how mental, physical and creative well-being are all essential facets of our existence.

'I'm not looking for uniqueness, I'm not looking for originality. I want to be genuine.'

Nástio Mosquito

B: 1981, Angola

It is brutal to discover that there are no new ideas. We buy into the myth that true creativity is presupposed upon entirely new ways of thinking and making, only to discover that we are influenced by everything that came before us. Nástio Mosquito is not shackled by such concerns, because he understands that every human has their own hopes and dreams. We are all the sum of unoriginal parts, but it is this assortment of viewpoints and sentimental notions that makes us authentic individuals.

Mosquito began pursuing his own dreams during dry spells of employment in the broadcasting industry. What began as DIY video and photography experiments have grown to encompass music, performance, installation and more. He embodies numerous characters, employing a mix of humour, confrontation and profanity to tackle issues of personal anxiety, identity politics, colonialism and commerce. He does not care to posit what his audience might think, instead focusing on the issues that concern him, and approaching them in a truly uninhibited manner. In *Demo Da Cracía* (2013), for example, he satirizes constructs of Angolan masculinity and a universal obsession with celebrity, while in *3 Continents* (2010) he highlights the destructive absurdity of imperialism through an imagined process of buying Europe, the USA and Africa outright.

Expulsion of Adam and Eve, 1512

'If people knew how hard I had to work to gain my mastery, it would not seem so wonderful at all.'

Michelangelo

B: 1475, Italy

Genius is '1 per cent inspiration and 99 per cent perspiration', according to Thomas Edison, and it appears that the great Renaissance master Michelangelo would have agreed. The artist rigorously honed his craft from the age of thirteen, working as an apprentice painter and then a sculptor, thanks to the support of the powerful Florentine ruler Lorenzo de' Medici.

Michelangelo rather begrudgingly accepted the commission to decorate the ceiling of the Sistine Chapel in the Vatican because he considered his painting skills to be inferior to his sculpting. Nevertheless, he undertook the mammoth four-year task (1508–12), enduring back-breaking physical strain and technical problems such as mildew caused by an ill-adapted plaster technique. He was also at the mercy of his commissioner, Pope Julius II, who grew so incensed by the slow progress that he reportedly threatened to throw the artist from the painting scaffolds.

Michelangelo despaired of his situation, so much so that he wrote a desolate letter to his friend Giovanni da Pistoia proclaiming, 'My haunches are grinding into my guts, my poor ass strains to work as a counterweight.' It was a gruelling sacrifice that nevertheless produced one of the greatest works of art of all time.

'Living consciously is living with art. It is quite simple and beautiful.'

N.S. Harsha

B: 1969, India

'Meditative' is a term that gets overused when seeking to explain an artist's methodology or process. It has often become synonymous with quiet working or a basic act of repetition, as opposed to something that truly moves into the realm of spiritual contemplation. By contrast, N.S. Harsha marries spontaneity and introspection to find equilibrium in the world and extract inspiration from his everyday surroundings, before translating them into his densely packed paintings, sculptures and site-specific installations.

One of his most fascinating methods involves regular trips to his local market in Mysore, where he lives and works. Amid the mayhem, he quietens his mind and focuses on just one colour, thus building a completely different dialogue with his surroundings. The ability to hone his consciousness in such a manner is reflected in his work, where the commonplace and the cosmic coalesce. He produces flat planes populated by hundreds of figures, which are reminiscent of traditional Indian painting, yet defined by surreal and often humorous contemporary concerns. Meanwhile, his fascination with the epic intangibility of the universe is encapsulated in deftly crafted celestial motifs, which are dwarfed within stunning, sweeping brushstrokes. Harsha proves that no subject is too large or too small – just take a deep breath and jump in.

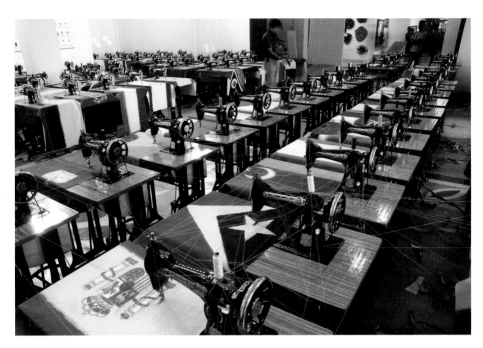

Nations, 2007

Punarapi Jananam come give us a speech, 2008

AN INTERVIEW WITH

N.S. HARSHA

'I never get bored of watching
the endless depths of the night
sky or moving clouds.'

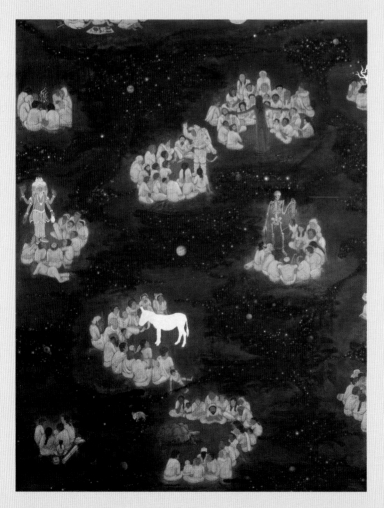

Warmth, 2019

Do you recall the first time a work of art had a profound impact on you?

The idea of a 'work of art' was only introduced to me when I got into art school. I grew up with an idea of 'chitra' – in Kannada it means 'image' – so there are many forms that kept me excited in my formative years, I suppose. The most significant ones could perhaps be Rangoli drawings [a traditional art form where patterns are drawn on the ground using coloured rice, flour, sand or flower petals usually to celebrate festivals and major life events], calendar images, book illustrations and sculptures found around temples and palaces.

I always found paintings in the Jaganmohan Palace intriguing; there are panels depicting everyday life as well as the life cycle of humans. There is also a pair of bronze lion sculptures that I used to play with, which was always fun!

Was there a moment when you knew you wanted to become an artist?

Not really; I never thought of 'becoming' an artist. But I have been deeply connected to drawing since childhood.

You once quoted Kiki Smith, who said that 'artists are not interior decorators for museums', and you are steadfastly attached to working in your studio in Mysore, away from the art world rat race. Why is it important for you to have this sense of removal, and do you feel a sense of responsibility to fulfil a particular role as an artist?

Kiki's comment is about being aware of an artist's relationship with museums, it is not against the museum. I was born in Mysore, which does not mean I was born 'away from the art world'. I like Mysore as a place to 'be'. I don't think about all these ideas of removal, responsibility, or the rat race – the

idea of betting on a fat rat! I feel that living consciously is living with art. It is quite simple and beautiful.

Speaking of living consciously, I watched a video in which you describe walking through the city market and using a technique in which you focus on a single colour, to calm the mind and discover new forms. How did you come upon this process, and how does it help your creativity? And is there any method to which colour you select?

Being in this process is in itself creative living. I don't do it with any other goal in mind. I love doing it, because I wish to live in the creative moment. The selection is made completely spontaneously, it's not as thought through as you have imagined.

Can you tell me about your definition of 'non-retinal' landscapes? For example, the idea of creating a panoramic view, without being constrained by ideas of true perspective or visual reality.

Landscape is a 'space', which is not necessarily for retinal reading. For example, a body is a landscape when you observe Lucian Freud figures. One gets to travel into a space of one's self through these images.

What is it about repetition that you find so compelling?

In my formative years (before 1995) my work was very expressionistic and leaned towards action painting. I lost faith in this mode and started searching for other streams of painting. At this point I experimented with the idea of mark making and 'chanting' with forms. I found this practice very exciting and at the same time it gave me some fresh visual outcomes. As a result, I began repeating, collecting and assembling distinct individuals, elements, forms and characters as a way of observing reality in everyday life. I like the visual flatness of my works when viewed from far, but upon closer observation they reveal hundreds of stories and mysteries. This is an interesting social metaphor for me.

The cosmos is a recurring motif in your work, whether it is a tiny reference in a piece such as *Smears to Weave Her Everyday* (2019) or the colossal never-ending loop in *Punarapi Jananam Punarapi Maranam (Again Birth – Again Death)* (2013). Why are you so interested in these celestial symbols?

The night sky has played an important role for me. People have asked me many times, 'are you a beach or mountain person?' I say I am 'sky' person – I strongly feel so. I never get bored of watching the endless depths of the night sky or moving clouds. Sometime in the early 1990s images of the cosmos started to appear in my works. They have been present in some form or another in my journey ever since then.

What about all the packaging you used for your enormous installation *Reclaiming Inner Space* (2017)? Does that relate to the cosmos in a more intangible way? You have the motif painted over these flattened boxes, but I think you've also referred to the hidden, dark space that exists within those packets, before they are deconstructed.

If one understands the cosmos in a dualistic manner, then these boxes exist within it. Consider the universe as one element from which actual reality unravels – the packets are part of the cosmos too! The dark spaces inside these boxes are the same dark spaces that exist in the celestial sphere – that is my understanding of cosmos.

You have mentioned that storytelling is an important aspect of your practice and that you draw inspiration from folklore and childhood tales. I wonder, does the humour that often inflects your work stem from these influences? I'm thinking of the way you might add an astronaut or a donkey to lighten the mood of a painting.

Mysore has a very good folklore museum, which has inspired me a lot, and I grew up with comic books and *Chandamama*, a Kannada-language periodical that had many stories [this influential pan-Indian title was published in multiple languages and celebrated folklore and moralistic tales], which do use humour.

I have read some texts that make me a storyteller, but I don't pay that much attention to what is being written about me. If I did, I might have to spend more time contesting what I am or working on the definition of a certain practice. The actual problem is that I don't know what I am. If I am a storyteller, then the tales are there in my cosmos paintings.

Is the physicality of painting an important part of your process? You appear to work in different gears, from minute, precise detailing to broad, gestural brushstrokes or handprints, often in the same work!

Being with 'paint' is exciting for me. What it does on a surface during the process is unpredictable and deeply governed by that moment of 'time'. So, scale follows painterly needs.

A major installation like *Nations* (2007/17) is an example of an entirely different form of art production. It is made up of rows of sewing machines that appear to be embroidering national flags, while in a gigantic tangle of thread. Why did this work need to be created in such a literal, physical way?

I don't think very consciously or cautiously when I am in the process of creative activity. So, I don't really know why *Nations* was

created. If one enters the installation, one does not see only flags and machines. There are many other details around it, which allow other metaphors to flow in. In pictures and reproductions it might look like a literal piece, but it could be more interesting to unpick the idea of 'literal' in the first instance.

Many of your major projects have held community at their core, particularly children's workshops. Has collective working always been an important means of expression for you? Or does it have a more altruistic basis?

These community projects are more about creating dialogues and platforms free from cultural boundaries or regional identities. I like the quality of thought in these situations. There are always a lot of surprises and developments, which were not necessarily pre-planned. These workshops also feed a lot of thoughts for my personal works in the studio. It is a different stream of creative activity, in the way that it involves more people and their thoughts. Again, I like doing these things with a clean mind, so don't know if it is for social good or self-good. Working with children is just 'good times' for me.

N.S. HARSHA

Born in Mysore, South India, where he lives and works, Harsha has exhibited extensively, with shows at the Mori Art Museum in Tokyo, the Dallas Museum of Art and the Ullens Center for Contemporary Art in China. He has staged artist workshops across Mysore, Bangalore, New Delhi and Hong Kong, and is a recipient of the Artes Mundi Prize.

'Everybody starts out by seeing a few works of art and wanting to do something like them.'

Gerhard Richter

B: 1932, Germany

Imitation is an important action in the history of art. From a young age we are taught that by copying the works of our heroes, we can gain something of their insight. Classical traditions have long seen students spend hours sketching furiously in sculpture and cast halls, and the art of facsimile has helped everyone from Vincent van Gogh to Bridget Riley better understand form and colour.

Gerhard Richter recognizes this methodology, but he does not subscribe to it. His epic oeuvre has been dominated by a quest to free painting from references to our lived existence, and instead allow the image to speak for itself and embody a reality of its own making. He separates his work from an art historical framework and reimagines the possibilities of paint. For example, the work pictured here is one of a series that takes photos of the artist's wife and young son as its starting point. Although this is indeed an act of copying in the first instance, it is not a likeness that Richter endeavours to capture, but is in fact a navigation of emotions ignited by using a spatula and squeegee to inflict various abstractions on to the image's surface.

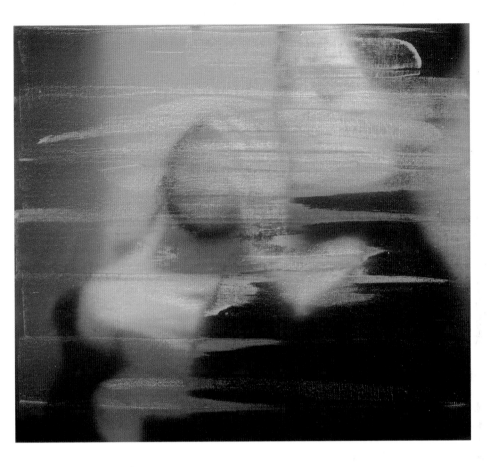

S. mit Kind, 1995

'What is most important is not so much what people see in the gallery or the museum, but what people see after looking at these things.'

Gabriel Orozco

B: 1962, Mexico

What are we all looking for when we talk about art's transformative power? Many of us might search for a lightbulb moment, an instance of life-changing significance that comes with crossing the threshold of an art space and gazing intently. But Gabriel Orozco thinks differently. He wants his work to shape the way we see the rest of the world, to forge new connections and ways of seeing beyond the walls of the gallery. To achieve this, he imagines everything in circles. He carves up the surface of a canvas, a photograph, the pavement – even a human skull and a whale skeleton – with intersecting curves.

This spirographic method does more than simply decorate an object; it creates movement and friction, forcing the eye to reconsider what it is consuming and recalibrating your brain in the process. Nowhere is this clearer than in *Dark Wave* (2006), one of two installations that sees the bone structure of a gigantic cetacean reimagined via a carefully sketched graphite lattice. Orozco refers to this action as topographical. He pinpoints the whale's centres of movement and spirals out from them, producing an organic network of rings that highlights the hidden geometries of every vertebrae, which encourages us to examine the remnants of this extraordinary beast with fresh eyes.

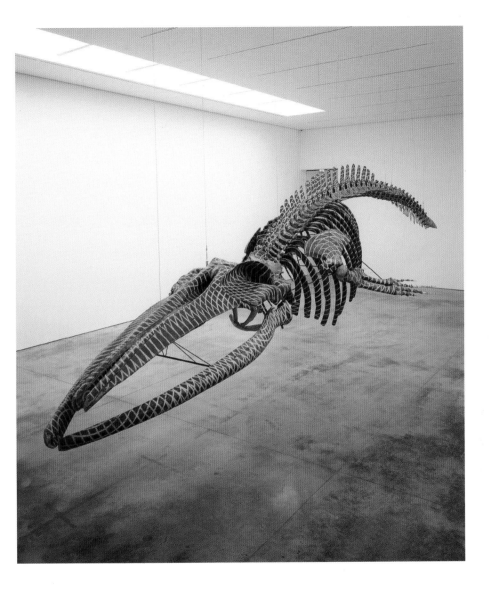

Dark Wave, 2006

Beneath lies the Power, 2014

'When you cut something up you need to take responsibility for the power you have over it.'

Wangechi Mutu

B: 1972, Kenya

How and why we use a chosen source material is something we should all be aware of – artist or otherwise. Appropriating images, objects and ideas is nothing new, but in the age of maximum visual overload the way we collect, dismantle and rehash media is more than a concern; it's a responsibility.

Wangechi Mutu considers the power of redefining the aesthetic and cultural value of an image in her mixed-media works, which combine painting and drawing with collages built from chopping up and reforming magazine cuttings, along with leather, vinyl, sand and much else. More often than not, these composites include dismembered elements of the female body, alongside all manner of objects including reptiles, plants, bones and machinery. In bringing these elements together, she creates new hybrid creatures that are both beautifully mythical and slightly grotesque, thus alluding to the way black womanhood is so often exoticized and misrepresented.

With each cut Mutu asserts ownership over her manipulation. She searches through fashion glossies, anthropological texts, pornography and medical diagrams, seeking out and slicing open their flawed and problematic messaging, before repurposing them. By considering the context of each cutting as much as its literal content, she subverts and rebuilds the tropes of visual culture.

'Muslims have been undertaking research on dots and lines – research that seemed so new when Kandinsky did it – since the first century of Islam.'

Saloua Raouda Choucair

B: 1916, Lebanon

This assertion from Saloua Raouda Choucair reminds us that the accepted path of art history is often a fallacy. As a Lebanese woman, Choucair found herself being considered in light of her peers, such as Fernand Léger; a follower as opposed to a trailblazer in her own right. The artist found this immensely frustrating, so much so that she wrote her own manifesto: *How the Arab Understood Visual Art*. It attested to roots of abstraction not stemming solely from the likes of Wassily Kandinsky and Paul Klee in the early twentieth century, but the earliest forms of Islamic art, which seek to capture the 'essence' of spirituality as opposed to figuration.

Nevertheless, Choucair was proclaimed Lebanon's first abstract artist, and her visual language did strike a path all of its own. She spoke of universal as opposed to European influence, producing paintings and sculpture (not to mention jewellery, furnishings and textiles) that mirrored her interest in mathematics, science and poetry via architectural, interlocking forms. Despite working prolifically and engaging critically with the global art scene, it was not until she was 97 years old that her legacy was acknowledged with a retrospective at Tate Modern in London, which just goes to show that the canon is never truly fixed.

Poem, 1963–65

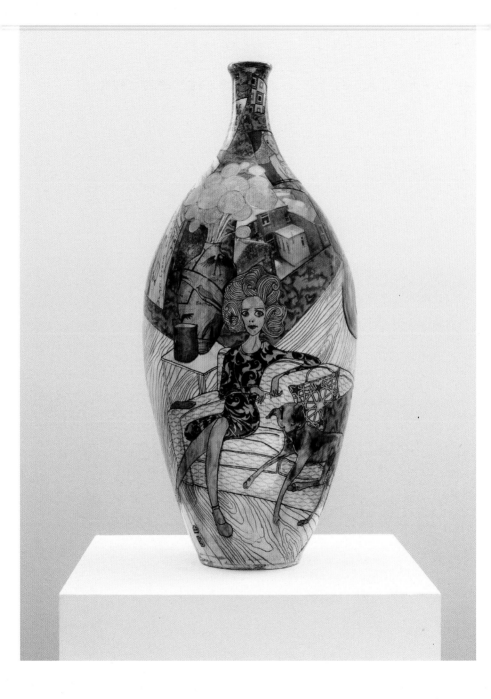

Thin Woman With Painting, 2019

'That's what all us artists do – super-rich interior decoration.'

Grayson Perry

B: 1960, UK

What is the difference between art and decoration? According to Grayson Perry, there's possibly very little. It is a jarring thought, which speaks to the realities of affluent collectors furnishing their private mansions, as opposed to relatively rare enshrinements in a museum or gallery. Known primarily as a potter, Perry lampoons this rather uncomfortable notion along with other myriad forms of societal anxiety. He embellishes his surfaces with such neatly coined phrases as 'social mobility' and 'iconic brand' alongside visual representations of expensively coiffed housewives and iterations of poverty and toxic masculinity. He also produces prints, tapestries, and even products such as handbags and yoga mats, as well as television shows that investigate British notions of taste.

It is telling that an artist who is concerned with how and why we define ourselves through objects prefers to use media that eschew the accepted forms of 'high art': sculpture and painting. He creates an uncomfortable schism that holds a mirror up to anxieties of the middle and upper classes while simultaneously fulfilling their desires. Perry revels in these contradictions, all the while noting that he is now a member of this 'cultural elite'. By battling the frontiers of 'good taste' he dares his audience to feel indignant, embarrassed, and perhaps even a touch ashamed.

'Without atmosphere a painting is nothing.'

Rembrandt van Rijn

B: 1606, The Netherlands

As a master of light and shadow, it comes as no surprise that Rembrandt championed atmosphere above all else. His dramatic chiaroscuro shrouds scenes in darkness, while illuminating subjects in a manner that is direct, yet subtle. His ability to capture the way light falls upon any surface is captivating, whether it be a glistening jewel on a lady's necklace, or the pallid flesh of a cadaver.

However, this is just one of the aspects of his art that imbue his paintings with such drama. He was also a genius when it came to humanizing his scenes, replacing the stiff formality typical of conventional portraiture with expressive vitality. Never is this truer than in *The Night Watch* (1642), one of the defining works of the Dutch Golden Age. It exploded the genre of civil guard portraits, which depicted wealthy guild members posing in a group, not unlike a class photograph. In Rembrandt's version, his patrons are scattered among a cacophonous crowd, accompanied by all manner of civilians, including a frightened girl and a snarling dog. The action is entirely of the artist's imagining but it feels palpable, as if the militia and their wards could step out into our world at any moment.

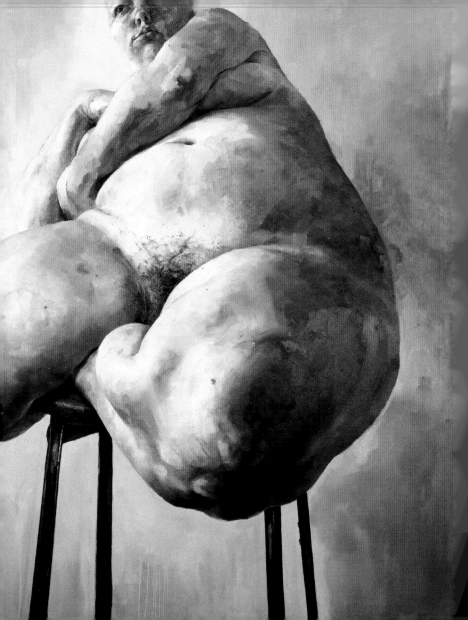

'I want to be a painter of modern life, and modern bodies.'

Jenny Saville

B: 1970, UK

Jenny Saville doesn't just paint bodies, she celebrates flesh. Her enormous canvases are filled with rolls of ruddy textural skin, as she celebrates women with bulging bellies and pendulous breasts through abrupt cropping and foreshortening. The arresting nature of these figures – by which I mean they do not fit the conventional beauty mould – first catapulted the artist into the limelight in the 1990s, when figurative painting was considered all but dead.

Saville's practice thrives in a moment when the very nature of the human body is changing. Flesh has become as malleable as the paint she uses to depict it. It can be cut up, reshaped, filled and flattened, and the visual cues that identify not only beauty, but also gender, have continued to expand. This shift is intimately connected to the digital age, where most of what we see is broadcast through a screen, compressing our perceptions of reality. So, what role does an oil painter have in such a world? I would argue, a significant one. The realism of Saville's painted flesh is infused with all of the ugliness and imperfections of our actual, non-airbrushed existence, even when it bears the mapping marks of a surgeon, or the ambiguity of multiple genders. Her corporeal world is an antidote to glossy inebriation, and it immortalizes an authentic reality that could one day disappear.

'I am interested in the uses and abuses of electricity.'

Iván Navarro

B: 1972, Chile

For Iván Navarro electric light is an essential artistic device that moves far beyond its basic aesthetic value. He is informed by memories of the Pinochet dictatorship in his native Chile, when the power grid was shut off regularly to control the public and electrocution was a state-sponsored form of torture. The weighted significance of this seemingly ubiquitous source of energy is interrogated via sculptures crafted from neon and fluorescent tubing. They often induce optical phenomena, engulfing you in strange rhythmic allusions as well as succinct and sometimes sinister wordplay.

When Navarro first moved to New York he was inspired by the ingenuity of the city's homeless communities and decided to explore the potential of moving 'off the grid'. He created a moveable sculpture that resembled a trolley and illuminated it by hacking into utilities at street level. In another performance, he lit up a bespoke bicycle through pure pedalled energy.

These interventions refuse to ignore how access to power has become an important facet of human existence. Without a basic provision of artificial light activity ceases, economies slump and the implication of threat increases. The artist also highlights its significance in the most fundamental manner: every one of his lit works lists 'electric energy' as a vital component.

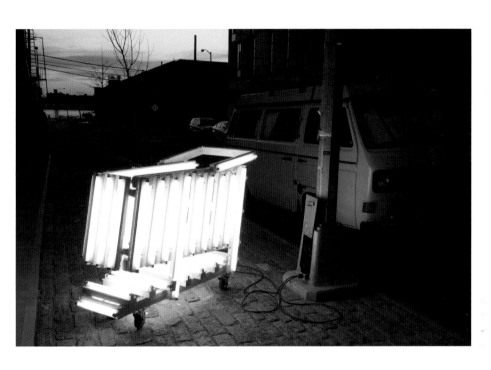

Homeless Lamp the Juice Sucker, 2004

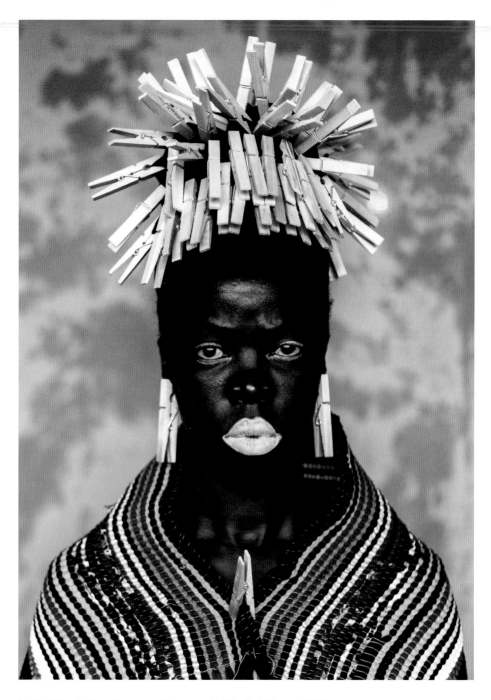

Bester I, Mayotte, from 'Somnyama Ngonyama: Hail the Dark Lioness', 2015

'Fine artists deal with finery, but I deal with painful material.'

Zanele Muholi

B: 1972, South Africa

Zanele Muholi is dedicated to amplifying the voices of marginalized queer communities and acknowledging the suffering that has been wrought in the wake of South African apartheid. Identifying as a 'visual activist' rather than an artist, they shun prescribed definitions of beauty and social significance supported by the colonial gaze, and focus on engaging with effective community-led activism. Muholi never refers to 'subjects' but rather 'participants' who take on a collaborative role in extensive projects such as 'Faces and Phases' (2006–), which documents the lives of black lesbian, gender nonconforming individuals and transmen.

The more recent series 'Somnyama Ngonyama: Hail the Dark Lioness' (2012–) focuses on the possibilities of the activist's own image as a black, non-binary person, informed by the prejudices experienced during extensive international travel. The itinerant image-maker takes self-portraits utilizing such ubiquitous materials as pegs, rubber tubes and sponges to build costumes that speak to various forms of South African heritage and often painful acts of historical record. By constructing such commanding images without any form of elaborate set-up, props or process, Muholi speaks to power, resilience and a unique form of ungilded magnificence.

'Some people have told me they remember the film that one of my images is derived from, but in fact I had no film in mind at all.'

Cindy Sherman

B: 1954, USA

There is an uncanny familiarity that comes with examining Cindy Sherman's photographs. Each carefully articulated shot features the artist in a different disguise, masquerading as everything from a movie star or flapper girl to society hostess or mediaeval queen. She conceives each character with insightful precision, manipulating her face with theatrical make-up, her body with distinct costuming, and her surroundings with an array of backdrops, before cementing the illusion in a single, deftly crafted shot.

It comes as no surprise then, that people recall all manner of cultural touchstones in a quest to decode her facade. Movies are an obvious starting point, not least because one of her earliest bodies of work 'Untitled Film Stills' (1977–80), alludes to various scenes from cinematic history. In imitating the angles, lighting and dramatization that typify the action on the big screen, Sherman manages to create an impression of domestic dramas, thrillers and erotic tales, but her references are never concrete. By embodying this uncertainty, she questions not only our consumption of visual culture, but the way we go about crafting the veneer of our individual identities.

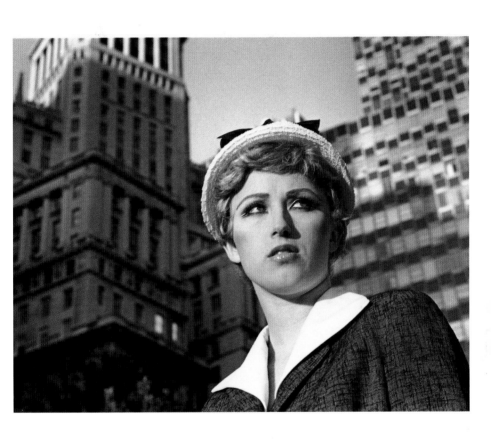

Untitled Film Still #21, 1978

If I had the words to tell you we wouldn't be here now, 2019

'Art should be accessible to everyone, not just those wealthy enough to collect it.'

Victoria Sin

B: 1991, Canada

Community is key for Victoria Sin. As a performance artist who has straddled the realms of club culture and contemporary art, they understand the importance of fostering inclusivity and carving out vital queer spaces, not only in the messaging of the work, but also in the actions that bring it into being.

Sin uses drag to vanquish the constraints of gender, moulding their own image into bombastic constructs of femininity, before astutely deconstructing them. They imagine alternative worlds of identity and expression – inspired by sci-fi, cinema and creative collaborations – and immerse you in performances that are at once sensual, philosophical and profound. Although Sin's commanding presence is awe-inspiring, they are not concerned with singular adoration. Instead, they describe their work as an incubator for thoughts and ideas, which embraces people and holds them close, building a collective experience where every voice is essential.

Performance is ephemeral by its very nature. It is difficult to collect, to quantify and price, and demands an audience in order to be active. This is why the form holds so much power for Sin – it thrives on shared experience. Every other facet of their practice is informed by it, whether it be beautiful operatic films, or the remnants of their made-up face imprinted on a wet wipe.

VICTORIA SIN

'It's really important to recognize making art is rarely a solo endeavour.'

As a performance artist you have become more and more present in the art world, but you started out in club and bar venues. What was your first point of entry into the drag scene?

Drag really came into my world when I started going out to gay bars in Toronto with my friends from my part-time job, who all happened to be gay men. It was exciting because I was under age and new to queer culture; I thought everything was so fabulous. The performers were incredible apparitions – I had never seen anything like them before. They were using femininity to subvert expectations of gender, sex and beauty, which was so thrilling for me, because I had always found it really hard to perform these ideals growing up. However, women were not really welcome in those spaces (I still identified as a woman at that point, not that it would have made much difference). I never thought that drag was something that I could be a part of until I moved to London, where I saw a completely different side to it. There were people from lots of gender backgrounds doing completely original things. You didn't have to be a cis man dressing up as a woman. That's when I realized that I could do drag – this thing that I always wanted to do but never thought was available to me – and what's more, it could be whatever I wanted it to be.

How did you begin exploring drag within your art practice?

I started performing at the same time that I was studying drawing at Camberwell College of Arts, but to begin with I kept them completely separate. Drag was something I did in a nightlife context, and it felt so personal that I didn't want to bring it into an art context in a way that didn't feel fully considered. It wasn't until I was studying my master's at the Royal College of Art, when I was looking at making film, that it made sense. Narrative cinema offered the perfect way for me to construct this very consumable image, while at the same time controlling the look, the way the camera consumes the body.

Can you also tell me about your relationship to lip-syncing? It is a very particular form of communication, but while most performers will mime along to someone else's voice, you record your own and incorporate your original writing. You also fragment the narrative by keeping your mouth shut at various points.

Drag queens didn't always lip-sync, but it caught on because it is such a simple, transcendental device; a queer technology. You can embody another identity so effectively and yet it is also a powerful example of disembodiment, because you are using that voice to step outside of yourself. I lip-sync as a way of detaching my voice from my body, confusing the positionality of the voice and the performer in order to question the origins of our language and ideas when we speak. Who is speaking? Who is being spoken to? The reality is that most people struggle to find their voice and figure out who they are in the world, because we have all been preconditioned in various ways. I feel very lucky to be queer and to do drag, because I have been able to put on and take off these ideas of femininity and gender and

Dragon Womxn, 2019

even race, which has helped me understand my relationship to my body and its relationship to the world.

Your work investigates the term 'language' in so many different ways, including visual, bodily, and the more abstract notion of how it is constructed and communicated. How did this become such an important concern?

I've always loved science fiction. I came to the genre because I wanted to escape to other worlds. Authors such as Octavia E. Butler, Samuel R. Delany and Ursula K. Le Guin provide this while also questioning societal structures and the way we are forced to define ourselves. They have all written on the theme of language, particularly in terms of gender, because gender is so present in language. In English it is difficult to speak about a person without mentioning it. It defines how we think and navigate the world.

Reading works of social science fiction helped me realize how culturally conditioned we are, how deeply power structures are embedded into our existence. I really want my performances to act as carrier bags that collect and incubate my ideas, and that completely envelop people.

Well, that is exactly what science fiction does, right? It builds entirely new worlds that you can get lost in.

Absolutely! We live in a world where there are a lot of different realities coexisting. It is really important to expose people to all of these different ideas around gender and identity and experience.

Recently I have noticed a shift in the way you present ideas of femininity. Originally there were lots of references to Western notions of beauty and the gaze in your hair, make-up and costuming, but your latest work seems to have a broader scope of references, including sci-fi and other cultural allusions. Was that a conscious decision?

For a long time, I was obsessed with embodying and disembodying Western femininity. I wanted to conquer it, to show everyone and myself how constructed it was. Now I have become more comfortable with my relationship to that image as someone who is mixed race, and I can move beyond that hegemonic Western representation of gender and beauty to recognize other visual languages that are important for me to explore. I began to incorporate different influences that I grew up with, such as Cantonese opera, which my grandmother sang and even taught me. When I was younger it had such a strong impact because it looked like nothing else I was being exposed to. I see it as my first encounter with non-Western queer representation, because there were women dressed in drag as men, who played romantic interests to other women. But to my grandmother, this wasn't queer at all.

The way you present yourself for each performance isn't fixed either, right?

That's true, it does shift. For example, when I performed *If I had the words to tell you we wouldn't be here now* (2018), in Chi-Wen Gallery in Taipei and later at the Venice Biennale, I looked completely different. Performance has become a really nice medium in which to work through and between different categories of identity and I have so many different ideas floating around, so I am often informed by the individual contexts. I wanted these two iterations to speak to their local visual and sonic languages. Besides costuming, in Taipei that meant collaborating with musician Peiju Lien, who plays the *pipa* [Chinese lute] and in Venice, with baroque flutist Matteo Gemolo.

Would you say collaboration is key to your practice? Plenty of artists work with others to produce their work, but it is still pretty rare for them to be so visibly credited in the way you do, which probably has something to do with upholding the myth of a singular artistic genius.

I think it's really important to recognize making art is rarely a solo endeavour. Often even when I finish a piece of writing – the base of a lot of my work – I'll present it to friends or peers because just having other eyes and ears on it immediately changes how you think about things. In the same way collaborators will bring new perspectives to your work and be more fluent in things like lighting or sound than you are. I can't perform every role in what is logistically speaking a theatre production, and of course, if someone has made me a beautiful, bespoke costume I'm going to post about it and credit the maker. It really should be obvious that I'm not doing all of this myself. It is so important to talk about who you are working with – you have to lift others up.

The contemporary art world is still struggling to categorize, not to mention commodify, performance-based practices. What has been your experience of creating work that can't be easily packaged up and sold?

There is very little consideration for the amount of time and effort that goes into making a performance; a lot of institutions still don't know how to treat it. In the context of capitalism, artists are expected to be attached to a gallery and produce work to sell in order to make money and survive, but that shouldn't be the only way. It's often painful to sell things that I see as important to part of my archive into private collections – I'm not sure if I or anyone else will ever see that work again. Art should be accessible to everyone, not just those wealthy enough to collect it. Performance builds a shared experience, an intimate immaterial moment in an impersonal commodified society. That's one of the beauties of it.

VICTORIA SIN
Born in Toronto, Sin is now based in London. They were part of the Venice Biennale's first performance programme in collaboration with the Delfina Foundation in 2019 and have also performed at the Serpentine Pavilion in London, Chi-Wen Gallery in Taiwan and MOCA Toronto. They have exhibited internationally, notably at London's Hayward Gallery, Taipei Contemporary Art Centre and the Palais de Tokyo in Paris.

'[Works that] address popular culture and specific contexts often get categorized as craft or design rather than art.'

Yinka Shonibare MBE

B: 1962, UK

Yinka Shonibare MBE touches on a poignant problem that permeates the arts – one of creative hierarchy. It is a complex pyramid marred by colonialism, sexism and downright snobbery, relegating certain aesthetics, materials, processes and even entire cultures to the periphery. Prime examples include an anthropological approach towards Pan-African art, and the notion of embroidery and textiles being 'women's work'; purely decorative and without true substance.

Shonibare rejects the accepted order by employing batik fabric as his primary motif. It is a material that has its own labyrinthine origins around the world, inspired by Indonesian design, mass-produced in The Netherlands and developed in West African colonies. He interrogates issues of race and class by cladding mannequins representing historical aristocracy and classical figures in this so-called 'African' textile, while simultaneously erasing the statues' identities by chopping off their heads or replacing them with globes. Such techniques subvert the systematic erasure of non-Western histories, not only recontextualizing but also texturizing these symbols of power by cloaking their hard surfaces in beautifully crafted hybrid garments and painted patterns.

Clementia, 2018

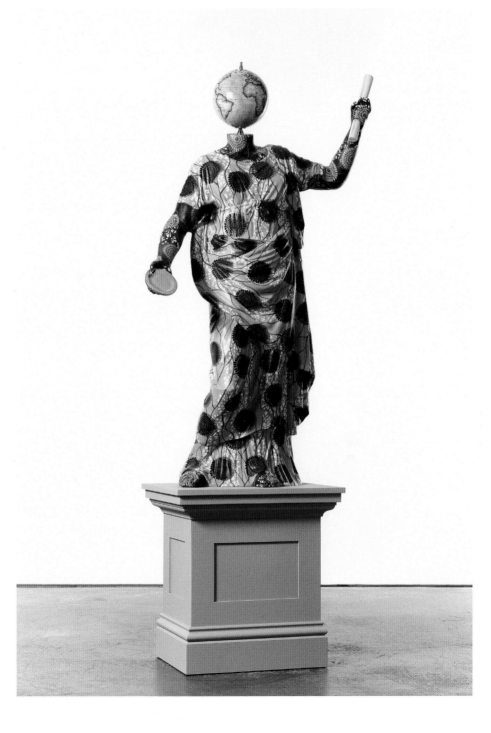

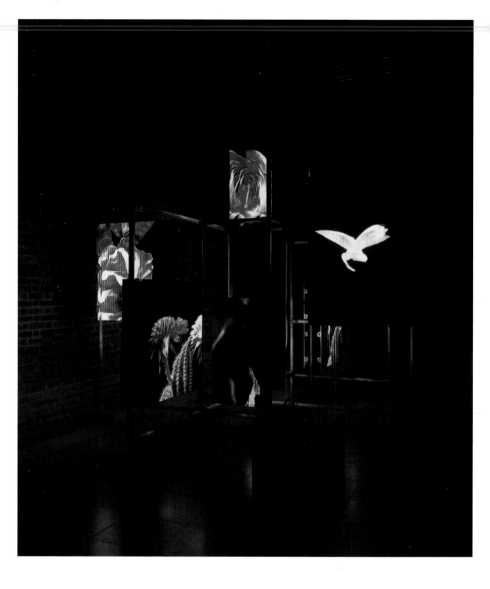

This Is The Future, 2019

'Poor images show the rare, the obvious, and the unbelievable'

Hito Steyerl

B: 1966, Germany

Hito Steyerl identifies a poor image by the digital measure that we have all become accustomed to using. 'Poor' equates to low resolution, pixelation and violent compression, all of the things we attempt to sift through and filter out while trawling through the internet. We have been conditioned to believe that this digital degradation destroys an image, rendering it if not entirely useless, then far inferior to its high-definition counterpart.

Steyerl, however, is fascinated by the rapid transmissions that are responsible for this new mode of visual dissemination, where authenticity, quality and copyright give way to a Möbius strip of torrents, file shares, bootleg uploads and video mash-ups. She explores these informational slippages through film and installation, making astute predictions on the possibilities of our future, and unpicking the many ways in which power structures are predicated on how our image is formed and shared. Steyerl proves that in this new hyper-digital age, it is not the carefully articulated painting or high-definition portrait that defines our lasting imprint, but a constant harvesting of grainy snapshots, blurred surveillance, social media selfies and web scrapes, most of which we never even knew existed.

'The person who has that authority of the gaze is always the sitter.'

Mickalene Thomas

B: 1971, USA

On the issue of power in the relationship between artist and sitter, history tells us that it is the former who holds all the cards. The gaze, whether it be male, female or otherwise, is usually considered to be a one-way street, in which the so-called creator defines the outcome through their particular vision.

Mickalene Thomas disagrees. She considers her work to be part of a collaborative process, which is often based on intimate relationships, such as that with her mother, Sandra 'Mama' Bush, and her partner, Racquel Chevremont. Each and every one of her depictions, whether it be a carefully articulated photograph, a collage, or a painting adorned with rhinestones and glitter, is bristling with power – there are no passive muses here.

Thomas celebrates environments familiar from childhood, ones populated by powerful, stylish black women and images of film stars such as Pam Grier, not to mention garish 1970s patterns and furnishings. Though she also references such art historical giants as Édouard Manet and Henri Matisse in her compositions, she wholeheartedly supplants the narrative by replacing their distant figures with the people who have shaped her existence. These works represent a world where sitters are far more than a vehicle for artistic expression; they are arbiters of their own image.

Le déjeuner sur l'herbe: Les Trois Femmes Noires, 2010

Amazing Grace, 1993

'Transformation has always been something that I romanticize in a work.'

Nari Ward

B: 1963, Jamaica

The act of transformation does not have to be literal. It can allude to the manner in which an object's meaning is altered by its surroundings, its placement, or a change in use, without physically altering its substance. Such nuance fascinates Nari Ward, who utilizes discarded objects found around the Harlem neighbourhood of New York City, where he lives and works, and ubiquitous items that relate to life in Jamaica, where he was born.

The notion of the 'readymade' was introduced by Marcel Duchamp, who sought to disrupt the idea of representational work by arguing that mass-produced objects could be declared art by the sheer will of the artist. Conversely, Ward understands that objects hold their own stories, which can shift depending on who is interacting with them and how they are presented. In *Amazing Grace* (1993), which includes a looped recording of the famous hymn, he installed hundreds of abandoned baby strollers in a formation that resembled the hull of a ship, while a carpet of fire hoses served as a walkway. The prams could relate to the marginalized people who use them to transport their possessions, the trials of motherhood, or enforced familial separation. The hoses originally related to the installation's primary set-up in an old fire station, but have since been interpreted as symbols of hope, transmutation and redemption.

'Different concepts may require different materials. Different locations may require different approaches.'

Mona Hatoum

B: 1952, Lebanon

While a devotion to a particular medium can be a mark of mastery, Mona Hatoum doesn't constrain her conceptual vision. The artist has always defied convention in her manifestations of human contradictions, utilizing everything from electrified kitchen utensils to iron filings to convey a palpable sense of threat, humour, desire and revulsion – sometimes all at once.

By maintaining a constantly inquisitive, experimental approach Hatoum maintains a distinct freedom, which is rooted in the power of materials – both their loaded meaning or lack thereof – and escapes any singular definition. She is not a sculptor, painter, video artist or performer; she is all and none at once. One need only encounter a work like *Hot Spot* (2006) with its glowing, electrified vision of global cartography, or *Untitled (wheelchair)* (1996), which turns a support device into a site of violence, to understand that every viewer's experience is defined by their own unique perception. By embodying inherent paradoxes, she exposes us to new ways of seeing and revels in the potency of subjectivity.

Hot Spot, 2006

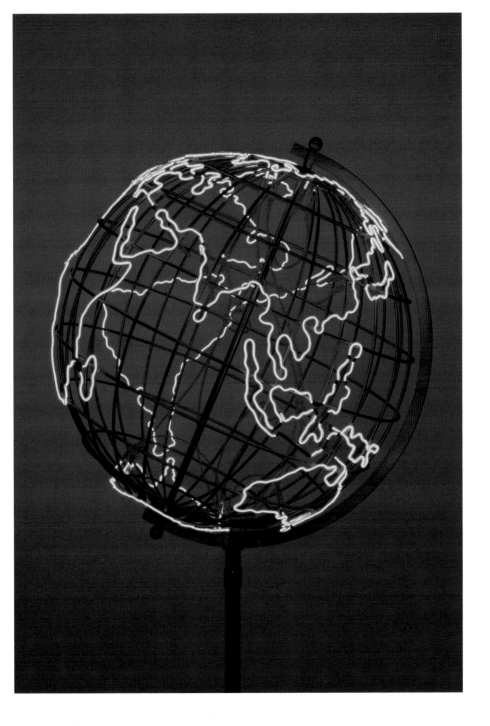

MONA HATOUM

'From very early on I have kept an experimental attitude to art.'

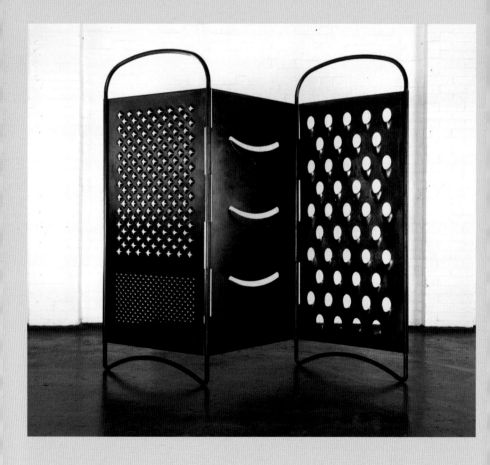

Grater Divide, 2002

You utilize an enormous variety of materials, from steel and concrete to human hair and found objects. Have you always been comfortable employing diverse materials as means to a conceptual end?

From very early on I have kept an experimental attitude to art. For me, there has always been a sense of discovery in exploring the phenomenological potential of materials; how their properties can work with the concept or provide an interesting contradiction. Both the materiality of minimalism and the intellectual rigour of conceptual art had a great impact on me as a student and I always felt that the form and concept are inseparable or work totally together to convey the meaning. On the one hand, I am interested in exploring geometry and abstraction, with the concept being subtly implied rather than directly stated. On the other, I often use found objects that are loaded with meaning and references.

I don't have a specific strategy and I don't restrict myself to one way of working. Different concepts may require different materials. Different locations may require different approaches. I have always insisted on the visual in my work, which is why materials are important to me. I like to engage people on a physical level first, with thoughts and associations coming out of this interaction.

Your early work has its roots in performance, in which your physical body played a significant role. What prompted a move towards an object-based, sculptural practice?

I had already been engaged in making sculpture and installations before I got involved in working in performance and video. When I got to my postgraduate course at the Slade School of Art, I found myself unable to carry on with the experimentations I was making because they were deemed too dangerous. Restrictions were imposed so I was only able to set up the installations in a controlled situation, for a limited time and for a small invited audience. These set-ups became like short demonstrations and that led me to making performances and video pieces. I carried on working in this way for most of the 1980s, which were turbulent years for me. The civil war was raging in Lebanon till the end of that decade and my work became more issue-based. I saw performance as a new and revolutionary form, which seemed to be right for the work I was making at the time.

A change in my circumstances took place in the late 1980s when I got a three-year fellowship in Cardiff and the job came with a great studio – the first I'd had since I left art school in 1981 – and a well-equipped sculpture workshop. It seemed natural to gravitate towards working with materials again, as I had the opportunity to learn some advanced skills for the first time, like various kinds of welding. I even made a wax bronze cast, since lost, in order to learn about the process. This is where I made my first large installation: *The Light at the End* (1989). It was the first opportunity I had to revisit some of the 'dangerous' materials I was not allowed to use during my student days. This was also the period when I developed two other large installations: *Light Sentence* and *Short Space* (both 1992) – both of which had a performative element and had a lot to do with the body of the viewer replacing my own and interacting directly with the installations.

Is the idea of a fluctuating energy important in your work? It is very visible in some cases and almost imperceptible in others.

In my early experiments as a student I was interested in working with what I called 'invisible forces' like electricity and magnetism, both of which can be quite dangerous.

It took almost ten years for me to revisit the idea of using electricity as a threatening force in the work *The Light at the End*, which was created specifically for the Showroom in London. It was an installation made with what, from a distance, looked like bars of light that created a gate-like structure blocking the narrow end of the gallery. When you got closer, you started experiencing an intense heat and realized that it was not light but electric heating elements that formed the bars of the gate. It looked like a situation of imprisonment, torture and pain.

Hot Spot (2006) is related to this in a way. It uses delicate red neon to outline the contours of the continents on a cage-like stainless-steel globe. The work implies that the whole world is ablaze with political conflict and unrest – or could also be a reference to global warming. Although the heat here is metaphorical, the work buzzes with an intense energy, giving it a menacing charge.

Also, as early as 1978, when I was on my first course at the Byam Shaw School of Art, I made a small work using magnets and iron filings. I used these materials again many years later for the work *Socle du monde* (1992–93), which is a large cube whose entire surface is covered in magnets and iron filings. It creates an ambiguous, seemingly soft and furry surface with a pattern reminiscent of the lobes of the brain or intestines.

The notion of threat seems pervasive in so much of your work. Is this rooted in a need to provoke a visceral response in people? To almost shock us out of our passive looking?

I suppose especially in the performances of the 1980s I was interested in provoking a visceral response and shaking a largely passive audience. Since the early 1990s, in the sculpture and installation work, this became more subtle, and more to do with wanting to make you question the real nature of what surrounds us.

Sometimes it can be about revealing an undercurrent of hostility. In *Untitled (wheelchair)* (1996), where the handles have been turned into sharp knives, it seems to be about exploring a contradictory psychological situation, where the potential user would need to rely on someone else to wheel them around and at the same time resent this dependence and wanting to harm them. But in a lot of cases the work speaks more of precariousness and the fragility of the human body. *Marrow* (1996) is a good example of this as it is a child's bed cast in a brownish rubber. It is called *Marrow* as in 'bone marrow' but without the rigidity of the bone structure to support it, it slumps on the floor like a collapsed body.

Recently, I feel that there is more of this concept of precariousness coming out of the work. The title of my 2019 exhibition at London's White Cube was 'Remains to be Seen', which suggests an uncertainty about the future. This condition sums up the current situation, not just in the UK, but all over the world. War, conflict, social unrest and natural disasters result in massive displacements of people and exile, and create feelings of precariousness, vulnerability, insecurity and a general anxiety about the future.

I read that your entry into the world of art was via surrealism, beginning with a book about René Magritte. Has the movement influenced the way you see the world?

Growing up in Beirut I was surrounded by psychology textbooks, a subject my eldest sister was studying at university. I was always dipping into her books despite the fact that I could hardly read English at the time. So, as a teenager I became aware of some Freudian concepts and the existence of a whole subconscious world and the way experiences of trauma can alter the way we interpret the world around us.

When I came across surrealism I saw it as a visualization of the subconscious and

the contradictions between reality and how we perceive it in our own particular way, depending on our individual experience. I saw it as a way of making art out of one's deep inner reality rather than through the logic of our minds.

I was especially interested in the work of René Magritte and the way he used visual puns and sometimes playfully altered the context or scale of objects in his paintings to challenge our perception.

I can see that influence in your treatment of domestic objects, where they have often been enlarged to a point of menace. Why have these seemingly mundane items been so significant for you?

The Freudian concept of the uncanny, of something familiar becoming strange or even threatening because it has been associated with some kind of trauma, has figured throughout my work in one way or another. Domestic furniture is supposed to give us support and comfort. When it becomes unstable and unable to fulfil its function, or even becomes dangerous, it makes us question the solidity and safety of the world around us. One way of making the familiar turn into an object of dread was to scale it up to surreal proportions. In *Mouli-Julienne (x21)* (2000) a vegetable grinder is turned into an infernal execution machine, reminiscent of The Harrow in Kafka's novel *The Penal Colony.*

Furniture and kitchen utensils are about the home and the nurturing that is expected, so when a disturbance is introduced, it contradicts our expectations and makes us question those assumptions. This is the case with *Homebound* (2000), where a group of domestic furniture and kitchen utensils become part of the 240V electric current that runs to lightbulbs that flicker and fade. At the same time the sound of the fluctuating current is amplified, adding to the sense of threat. So, it speaks more of domestic entrapment or confinement of domesticity. With its fence denying access, it can be seen as a condemned home or a denied homeland.

Going back to Magritte's puns, is humour something you would like people to find in your art? Some of your titles use wordplay, which almost dares us to find a more amusing facet to these formidable pieces.

Yes, humour has been important in my work and I often combine it with a touch of surrealism to contradict or deflate some of the serious issues. This has been present since early works like *Roadworks*, a performance from 1985 where I walked barefoot in the streets of Brixton dragging heavy police boots behind me as if I was being followed by an invisible policeman, or the 1988 billboard *Over my dead body* where the symbol of masculinity was reduced to a toy soldier stuck to my nose.

And, as you mentioned, the humour can be simply a pun or a wordplay in the title of the work. 'Remains to be Seen' is also the title of a large installation that looks like the actual remains of a demolished building. Thank god for humour!

MONA HATOUM

A Palestinian artist who was born in Lebanon, Hatoum lives and works in London. She has been the recipient of numerous awards including the 2011 Joan Miró Prize, the 10th Hiroshima Art Prize and the Praemium Imperiale for her contribution to the field of sculpture. Major solo shows have been staged at the Museum of Contemporary Art in Chicago, the Centre Pompidou in Paris, Tate Modern in London and Castello di Rivoli in Turin.

'Drawing made my world less small, and so in my act of drawing I hope to make the world less small for other people.'

Toyin Ojih Odutola

B: 1985, Nigeria

Drawing is often regarded as a form of preparatory study at best and mindless doodling at worst, yet for Toyin Ojih Odutola it is the ultimate tool for storytelling; where she seeks to 'interpret, rather than describe'. Never is this truer than in *A Countervailing Theory* (2020), an epic fictional narrative that depicts an ancient civilisation, told through the lens of a forbidden love story. Each work in the forty-piece series sheds light on the complex existence of the *Eshu* (a ruling class of warrior women) and the *Koba* (humanoid male labourers), reflecting upon the societal power structures and imprints that exist both in their realm and our own.

These fantastical depictions are set within a surreal landscape inspired by the rock formations of Nigeria's Plateau State, but it is not only their cinematic aesthetics that grip the imagination. Each drawing begins with a wholly black surface, on which charcoal, pastel and chalk are etched, thereby breaking with the prevailing tradition of a white foundation as default. Through this act, Ojih Odutola asks us to question the accepted constructs of our existence and ignites a world of possibilities in the process.

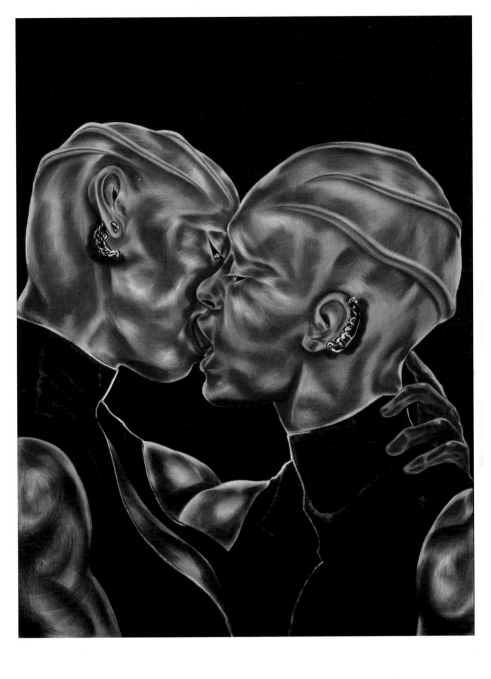

A Parting Gift; Hers and Hers, Only from *A Countervailing Theory*, 2019

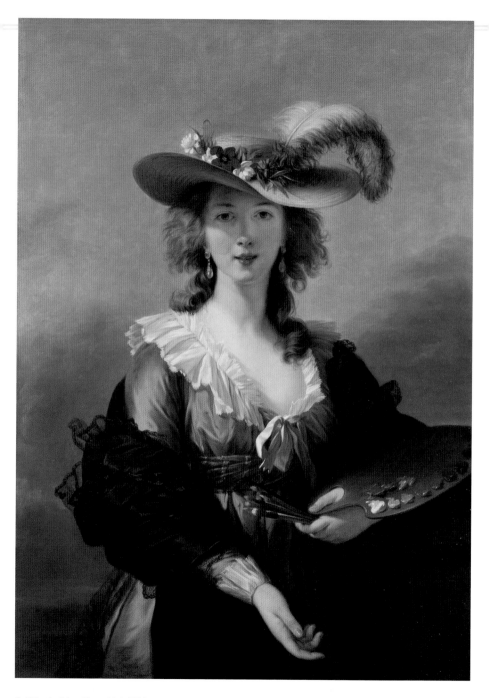

Self Portrait in a Straw Hat, 1782

'I have never made the smallest excursion, not even a walk without bringing back some sketches.'

Élisabeth Vigée Le Brun

B: 1755, France

There is never an excuse not to make art, according to the French portraitist Élisabeth Vigée Le Brun. This tenacious artist was instilled with an obsessive need to create in childhood, when she used every conceivable surface as a canvas, from school books to the classroom wall. By the time she was a teenager she was enticing the gentry with a new form of portraiture that replaced formality with naturalistic intimacy, and she soon became a veritable celebrity thanks to the patronage of Marie Antoinette, for whom she produced no fewer than 60 paintings. When revolution came the artist fled to Naples, Vienna and St Petersburg, delighting society with her new French style.

Necessity can often be a galvanizing force for creativity, and for Le Brun art was not only her passion, but also a valuable means of income. She was effectively a single parent, in a world where professional opportunities for women were virtually non-existent, and her need to provide meant she barely put down her brushes. In this self-portrait (from 1782) she shares the flushed cheeks and relaxed composure of her aristocratic sitters, but while they might clutch a flower or letter, she brandishes the vital tools of her trade.

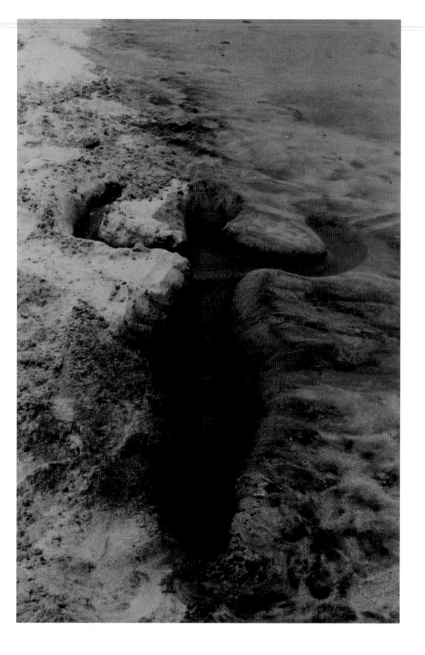

Silueta Works in Mexico (series), 1973–77/1991

'I'm not interested in the formal qualities of my materials, but their emotional and sensual ones.'

Ana Mendieta

B: 1948, Cuba

Ana Mendieta's practice was inextricably tied to the land. Taking the silhouette of the female figure as her starting point, she created bodily interventions that bonded her imprint with the landscape via rock carvings, outlines of fire, water-filled cavities and more. Although Mendieta was far from the only artist of the mid-twentieth century forging a connection with the natural world, she managed to capture something instinctual and almost primordial through her temporary impressions. While Robert Smithson's gigantic *Spiral Jetty* (1970) and Walter De Maria's *The Lightning Field* (1977) harness the mighty, enduring power of the elements, Mendieta's works speak of the ethereal forces of ritual and ceremony, informed by her Cuban identity, as well as indigenous Central American and Afro-Caribbean religions.

Although the artist certainly championed emotion and sensuality, there was nothing whimsical about her practice. She used animal materials including blood in her more explicit performances, alluding to Catholic dogma, violence against women and the slaughter employed in Viennese Actionism. In these messy, volatile moments she did not value the aesthetic qualities of these substances, but the visceral, base connection they evoke in all of us.

'An artwork unable to make people feel uncomfortable or to feel different is not one worth creating.'

Ai Weiwei

B: 1961, China

For Ai Weiwei art and activism are inseparable. The Chinese dissident artist has lived under different forms of governmental persecution since his childhood (which was partially spent in a labour camp), including incessant surveillance, arrests, detainment and harassment. This experience has led Ai to identify with the victims of the refugee crisis, a humanitarian disaster that has instigated the global displacement and subjugation of millions of people. While the artist's work has always been subversive – he made headlines back in the 1990s by smashing Han Dynasty vases and painting others with the Coca-Cola logo – his statements have become more direct, informed by his time visiting migrants in camps across the world, from Greece to Lebanon to Kenya, and experiencing their plight first-hand.

Though the notion of 'political art' takes many forms, Ai's recent work largely does away with analogy, instead confronting us with the darkest realities of this crisis. He presents collections of photographs and videos taken during his travels and produces sculptures that force us into literal comprehension. They feature vessels akin to those used for perilous crossings, and the very life jackets worn by so many in an attempt to ensure their survival. Such objects are uncomfortable to encounter and impossible to ignore.

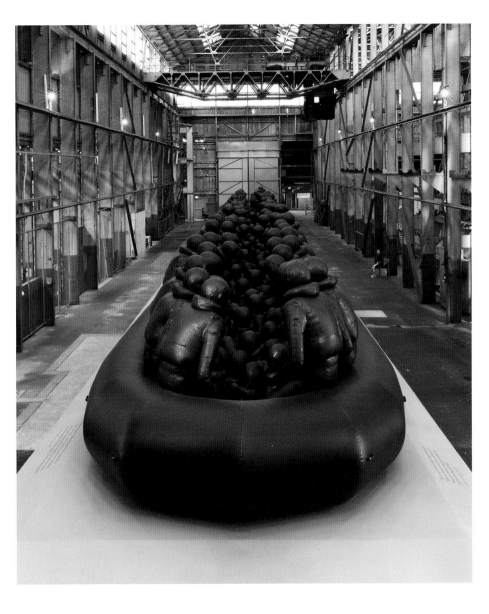

Law of the Journey, 2017

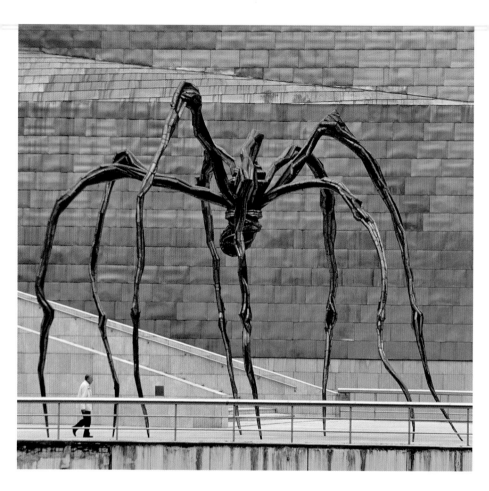

Maman, 1999

'I am not what I say, I am what I do.'

Louise Bourgeois

B: 1911, France

Louise Bourgeois' statement doesn't exactly chime with the idea behind this book. If we didn't want to hear what artists have to say about their work, then what are we doing here? But in reality, her declaration holds much truth. The art world is full of talk, from lengthy criticism and curatorial theses, to artist statements and museum wall texts. This can be enlightening, but also confounding. As viewers, at the behest of much theorizing and rationalization, we can fail to experience what is right in front of us, for fear of 'getting it wrong'. Likewise, artists can find themselves stripped of inspiration when facing the din of opinion – including their own.

Plenty of artists would prefer not to speak about their practice at all, confident in the fact that art should speak for itself. In Bourgeois' case, this is certainly true. Her gigantic spider sculptures are an assault on the senses. Both nightmarish and alluring, their heavy egg sacs allude to maternal protection, while their sinewy limbs appear violent and cruel. Such formidable forms might well leave you speechless.

FURTHER READING

Berger, John. *Ways of Seeing* (Penguin, 1972).

Cogeval, Guy and Bakker, Nienke. *Splendours & Miseries: Images of Prostitution in France, 1850-1910* (Flammarion, 2016).

Emin, Tracey. *Strangeland* (Hodder & Stoughton, 2006).

Jansen, Charlotte. *Art and Photography in the Age of the Female Gaze* (Laurence King Publishing, 2017).

Nochlin, Lina. *Women, Art, And Power And Other Essays* (Taylor & Francis Inc, 1988).

Noey, Christopher (ed.). *The Artist Project, What Artists See When They Look At Art* (Phaidon, 2017)

Murrell, Denise. *Posing Modernity, The Black Model from Manet and Matisse to Today* (Yale University Press, 2018).

Ojih Odutola, Toyin. *Toyin Ojih Odutola: A Countervailing Theory* (Barbican, 2020).

Pardo, Alona (ed.). *Masculinities: Liberation through Photography* (Prestel, 2020).

Perry, Grayson. *Cycle of Violence* (Atlas Press, 1993).

Sin, Victoria. *A View from Elsewhere* (PS/Y for Hysteria, 2018).

QUOTATION SOURCE CREDITS

8 Yasumasa Morimura: Yasumasa Morimura, *Daughter of Art History. Photographs by Yasumasa Morimura*, Aperture, 2003, page 113; **11** Njideka Akunyili Crosby: https://www.youtube.com/watch?v=HPU8W2×BBf4; **12** Marina Abramović: *Marina Abramović, James Kaplan, Walk Through Walls: A Memoir*, Crown Archetype, 2016; **15** Katsushika Hokusai: https://top.britishmuseum.org/hokusai-old-master/; **16** Lisa Reihana: Original interview, 2 December 2019; **22** Cao Fei: Serpentine Galleries press release, *CAO FEI: BLUEPRINTS*, 19 December 2019; **24** El Anatsui: https://www.youtube.com/watch?v=_d3RIE195JI; **27** Mark Rothko: Mark Rothko, *The Artist's Reality: Philosophies of Art*, Yale University Press, 2004, page 2; **28** Marisol Escobar: Jeff Goldberg, 'Pop Artist Marisol—20 Years After Her First Fame—Recalls Her Life and Loves', *People*, March 24, 1975; **31** Theaster Gates: Theaster Gates in conversation with Tim Marlow at White Cube Bermondsey, 8 October 2012; **32** Max Beckmann: Peter Selz, with contributions by Harold Joachim and Perry T. Rathbone, Max Beckmann, Museum of Modern Art, 1964, page 132; **35** Jenny Holzer: https://www.interviewmagazine.com/art/jenny-holzer; **36** Ibrahim El-Salahi: Salah M. Hassan, *Ibrahim El-Salahi: A Visionary Modernist*, Tate Publishing, 2013, page 111; **39** Felix Gonzalez-Torres: Felix Gonzalez-Torres, A.R.T. Press ; New York, 1993, p7; **40** Lubaina Himid: https://www.theguardian.com/artanddesign/2017/sep/24/lubaina-himid-turner-prize-2017-interview; **42** Abdoulaye Konaté: https://www.exberliner.com/whats-on/art/abdoulaye-konate-interview/; **45** Lee Bul: https://www.japantimes.co.jp/culture/2012/04/05/arts/lee-bul-inspired-by-the-past-imperfect-2/#.Xe_NDy2cbVo; **46** Shilpa Gupta: https://asiasociety.org/video/studio-shilpa-gupta?page=1; **49** Tracey Emin: original interview, November 2019; **54** Arthur Jafa: https://www.youtube.com/watch?v=Byzvuq9yY7c; **57** Susan Hiller: Barbara Enzing, ed., 'Belshazzar's Feast/ The Writing on your Wall, an interview with Catherine Kinley', *Thinking About Art: Conversations with Susan Hiller*, Manchester University Press, 1996, page 89; **58** Kerry James Marshall: https://africanah.org/kerry-james-marshall-i-call-attention-absence-black-presence/; **61** Nam June Paik: Exhibition text, *Nam June Paik*, Tate Modern, 17 October 2019 – 9 February 2020; **62** Anselm Kiefer: Exhibition tour, *Anselm Kiefer: Superstrings, Runes, The Norns*, *Gordian Knot*, 14 November 2019; **64** Barbara Kruger: https://www.anothermag.com/art-photography/362/barbara-kruger; **67** Yayoi Kusama: Grady Turner and Yayoi Kusama, 'Yayoi Kusama', *BOMB*, no. 66 (1999): pages 62–69; **68** Nástio Mosquito: https://channel.louisiana.dk/video/nástio-mosquito-what-are-you-willing-die; **71** Michelangelo: https://news.artnet.com/art-world/michelangelo-art-forgery-742172; **72** N.S. Harsha: original interview, November 2019; **78** Gerhard Richter: https://www.gerhard-richter.com/en/quotes/mediums-3/painting-15; **80** Gabriel Orozco: http://www.artnet.com/artists/gabriel-orozco/; **83** Wangechi Mutu: https://elephant.art/wangechi-mutu/; **84** Saloua Raouda Choucair: https://www.mitpressjournals.org/doi/pdf/10.1162/ARTM_a_00107; **87** Grayson Perry: Exhibition tour, *Grayson Perry: Super Rich Interior Decoration*, Victoria Miro Mayfair, 24 September 2019; **88** Rembrandt van Rijn: attributed to the artist; **91** Jenny Saville: https://www.theguardian.com/artanddesign/2012/jun/09/jenny-saville-painter-modern-bodies; **92** Iván Navarro: Julia P. Herzberg, ed., *Iván Navarro: Fluorescent Light Sculptures*, The Patricia & Philip Frost Art Museum, 2013, page 57; **95** Zanele Muholi: https://www.bbc.co.uk/programmes/articles/12VHc6SJ36ySTKICSYG1swY/pride-and-prejudice-how-zanele-muholi-documents-south-africas-lgbti-community; **96** Cindy Sherman: https://reallifemag.com/still-lives; **99** Victoria Sin: Original interview, November 2019; **104** Yinka Shonibare MBE: Yinka Shonibare, *Criminal Ornamentation*, Hayward Gallery Publishing, 2018, page 10; **107** Hito Steyerl: https://www.e-flux.com/journal/10/61362/in-defense-of-the-poor-image/; **108** Mickalene Thomas: Mickalene Thomas, *I Can't See You Without Me*, Wexner Center for the Arts, 2018; **111** Nari Ward: https://bombmagazine.org/articles/nari-ward/; **112** Mona Hatoum: interview with author, November 2019 **118** Toyin Ojih Odutola: PBS News Hour, Brief but Spectacular: https://www.youtube.com/watch?v=9N3XMDzfK0k; **121** Élisabeth Vigée Le Brun: L. Vigée-Lebrun, M. Franklin Tyler, Souvenirs of Madame Vigée Le Brun, Worthington, 1879, page 155; **123** Ana Mendieta: Kaira M Cabañas, Ana Mendieta, 'Pain of Cuba, Body I Am', *Woman's Art Journal*, Vol. 20, No. 1 (Spring – Summer, 1999), pages 12–17; **124** Ai Weiwei: Ai Weiwei, Roger Conover, Ai Weiwei's Blog: Writings, Interviews, and Digital Rants, 2006–2009, MIT Press, 2011; **127** Louise Bourgeois: https://henitalks.com/talks/louise-bourgeois/#transcript.

PICTURE CREDITS

9 © Yasumasa Morimura; Courtesy of the artist and Luhring Augustine, New York; **10** © Njideka Akunyili Crosby, Courtesy the artist, Victoria Miro, and David Zwirner; **13** © Marina Abramović. Courtesy of Marina Abramović Archives and Sean Kelly Gallery, New York DACS 2020, **14** Metropolitan Museum of Art, NY; H. O. Havemeyer Collection, Bequest of Mrs. H. O. Havemeyer, 1929. Accession Number: JP1847; **17** © Lisa Marie Reihana/Licensed by DACS 2020; **18** © Lisa Marie Reihana/Licensed by DACS 2020; **23** Courtesy of artist, Vitamin Creative Space and Sprüth Magers; **25** © El Anatsui. Courtesy of the artist and Jack Shainman Gallery, New York; **26** Tate. Purchased 1959. T00275, © 1998 Kate Rothko Prizel & Christopher Rothko ARS, NY and DACS, London; **29** Purchase, with funds from the Friends of the Whitney Museum of American Art. Scala/© Estate of Marisol/ARS, NY and DACS, London 2020; **30** © Theaster Gates, Photo © White Cube (Ben Westoby); **33** Private Collection/Bridgeman Images/© DACS 2020; **34** © 2019 by the author. From the documents That Survive website of everytown.org, September 20, 2019. Used with permission of the author. Presented by Creative Time, Photo: Lauren Camarata. © Jenny Holzer, ARS, NY and DACS London 2020; **37** © Ibrahim El-Salahi. All rights reserved, DACS 2020; **38** The Solomon R. Guggenheim Museum, New York, NY. 3 Mar. – 10 May 1995. Cur. Nancy Spector, Photographer: David Heald, Image courtesy of The Solomon R. Guggenheim Museum, © Felix Gonzalez-Torres. Courtesy of the Felix Gonzalez-Torres Foundation; **41** Tate, Presented by the Patrons of New Art (Special Purchase Fund) through the Tate Gallery Foundation 1995. T06947; **43** Image courtesy the artist and Primo Marella Gallery, Milan; **44** Image courtesy the artist and Marici Lab Space; **47** Courtesy: The Artist. Commissioned by: Lyon Biennial '09, Photographer: Ela Bialkowska, OKNO Studio; **48** © Tracey Emin. All rights reserved. DACS /Artimage 2020; **50** © Tracey Emin. All rights reserved. DACS /Artimage 2020; **55** Courtesy the artist and Gavin Brown's enterprise, New York/Rome; **56** Tate, Purchased 1984. T03923, © Susan Hiller. All rights reserved. DACS 2020; **59** © Kerry James Marshall, Courtesy the artist and David Zwirner, London; **60** © The Estate of Nam June Paik; **63** Photo: Georges Poncet, © Anselm Kiefer. Image courtesy Gagosian Gallery; **65** Courtesy the artist and Sprüth Magers; **66** Collection Stedelijk Museum, Amsterdam, Courtesy the artist, Ota Fine Arts and Victoria Miro.© Yayoi Kusama; **69** Images courtesy the artist; **70** © Mondadori Portfolio/Bridgeman Images; **73** top: © NS Harsha, Courtesy the artist and Victoria Miro and bottom: © NS Harsha; **74** © NS Harsha, Courtesy the artist and Victoria Miro; **79** © Gerhard Richter 2020 (0114)); **81** © Gabriel Orozco. Photo © Stephen White, Courtesy White Cube; **82** © Wangechi Mutu, Courtesy the artist and Victoria Miro; **85** Tate, Presented anonymously 2011. T13278, © Saloua Raouda Choucair Foundation; **86** © Grayson Perry, Courtesy the artist and Victoria Miro; **90** © Rijksmuseum, Amsterdam; **90** © Jenny Saville. All rights reserved. DACS 2020, Courtesy the artist and Gagosian; **93** © ADAGP, Paris and DACS, London 2020, Courtesy of the artist and Templon, Paris - Brussels. Photo: Thelma Gracia; **94** © Zanele Muholi. Courtesy of the artist, Yancey Richardson, New York, and Stevenson Cape Town/ Johannesburg; **97** Courtesy of the artist and Metro Pictures, New York; **98** Photo: Ivy Tzai; **100** Courtesy: the artist; **105** Image courtesy of the artist and Goodman Gallery, © Yinka Shonibare CBE. All Rights Reserved, DACS 2020; **106** Courtesy of the Artist, Andrew Kreps Gallery, New York and Esther Schipper, Berlin, Photograph: © 2019 readsreads.info./© DACS 2020; **109** The Rachel and Jean-Pierre Lehmann Collection, © Mickalene Thomas/© ARS, NY and DACS, London 2020; **110** Courtesy the artist and Lehmann Maupin, New York, Hong Kong, and Seoul, Photo: Maris Hutchinson/EPW Studio; **113** Photo © and courtesy White Cube (Photo: Ollie Hammick), © Mona Hatoum 2020; **114** Photo © and Courtesy White Cube (Photo: Iain Dickens), © Mona Hatoum 2020; **119** © Toyin Ojih Odutola. Courtesy of the artist and Jack Shainman Gallery, New York; **120** National Gallery, London, G.L. Archive/Alamy; **124** The Museum of Contemporary Art, Los Angeles, Purchase with a grant provided by The Judith Rothschild Foundation. © ARS, NY and DACS, London 2020, **125** Courtesy the artist and Lisson Gallery; **126** Alamy/Uwe Kazmeir/imageBROKER/© The Easton Foundation/VAGA at ARS, NY and DACS, London 2020.